POSTERS
THE COLD WAR

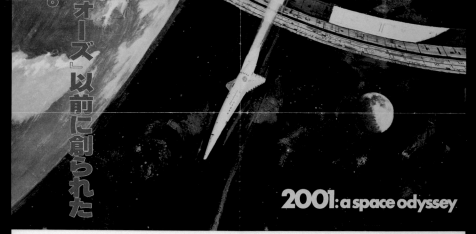

2001: a space odyssey

『スター・ウォーズ』のジョージ・ルーカス監督は『2001年宇宙の旅』について言う。

スタンリー・キューブリックは究極的なSF映画を創った。そして、どんな人でもこれ以上の映画を製作することは非常に困難なことであろう。
技術的に比較することは出来るが私は『2001年宇宙の旅』が遙かに優れていると思う。

製作・監督スタンリー・キューブリック

2001年宇宙の旅

〈カラー作品〉

脚本スタンリー・キューブリック／アーサー・C・クラーク ■原作邦訳(早川書房刊)サントラ盤(MGMレコード)

主演キア・デュリア／ゲーリー・ロックウッドMGM映画 CIC配給

映倫

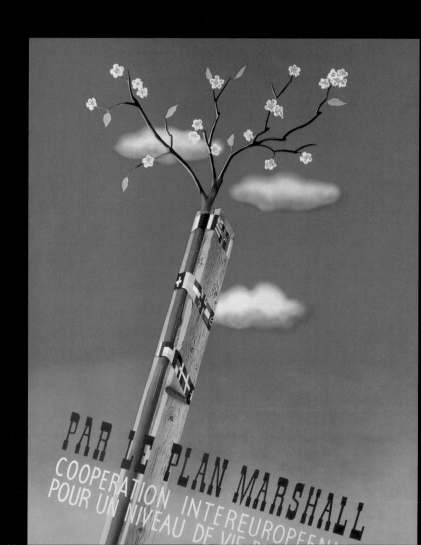

PAR LE PLAN MARSHALL
COOPERATION INTEREUROPEENNE
POUR UN NIVEAU DE VIE

POSTERS OF
THE COLD WAR

BY DAVID CROWLEY

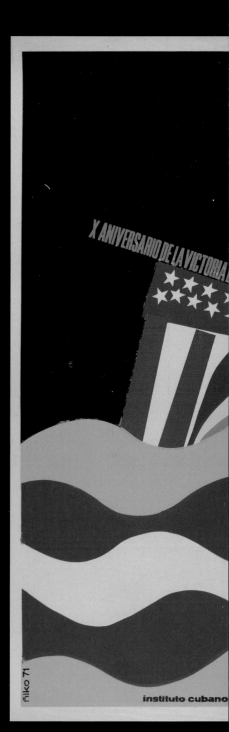

V&A PUBLISHING

First published by V&A Publishing, 2008
V&A Publishing
Victoria and Albert Museum
South Kensington
London SW7 2RL

Distributed in North America by
Harry N. Abrams, Inc., New York

Paperback edition
ISBN 978 1 85177 545 3
Library of Congress Control Number 2008924013

10 9 8 7 6 5 4 3 2 1
2012 2011 2010 2009 2008

A catalogue record for this book is available
from the British Library.

Designed by Practise, London
James Goggin & Annette Lux
Copy-edited by Delia Gaze

New V&A photography by Paul Robins,
V&A Photographic Studio

Front cover illustration: p.50
Back cover illustrations: pp.106–107, 73, 52

Printed and bound by Printing Express, Hong Kong

Acknowledgements
I would like to thank Gigi Chang, Catherine Flood,
Maria Mileeva, Jane Pavitt, Jana Scholze, Margaret Timmers
and Zoe Whitley for the advice that they have kindly
given me in the preparation of this book. For the production
of the book I would like to thank Paul Robins of the
V&A Photo Studio, Asha Savjani, Anjali Bulley,
Clare Davis, Mark Eastment and Geoff Barlow of V&A
Publishing, Delia Gaze for copyediting and James Goggin
and Annette Lux of Practise for their thoughtful design.
My thanks also go to Eliza Brownjohn and those
individuals who have allowed posters in their collections
to be reproduced —DC

V&A Publishing
Victoria and Albert Museum
South Kensington
London SW7 2RL

www.vam.ac.uk

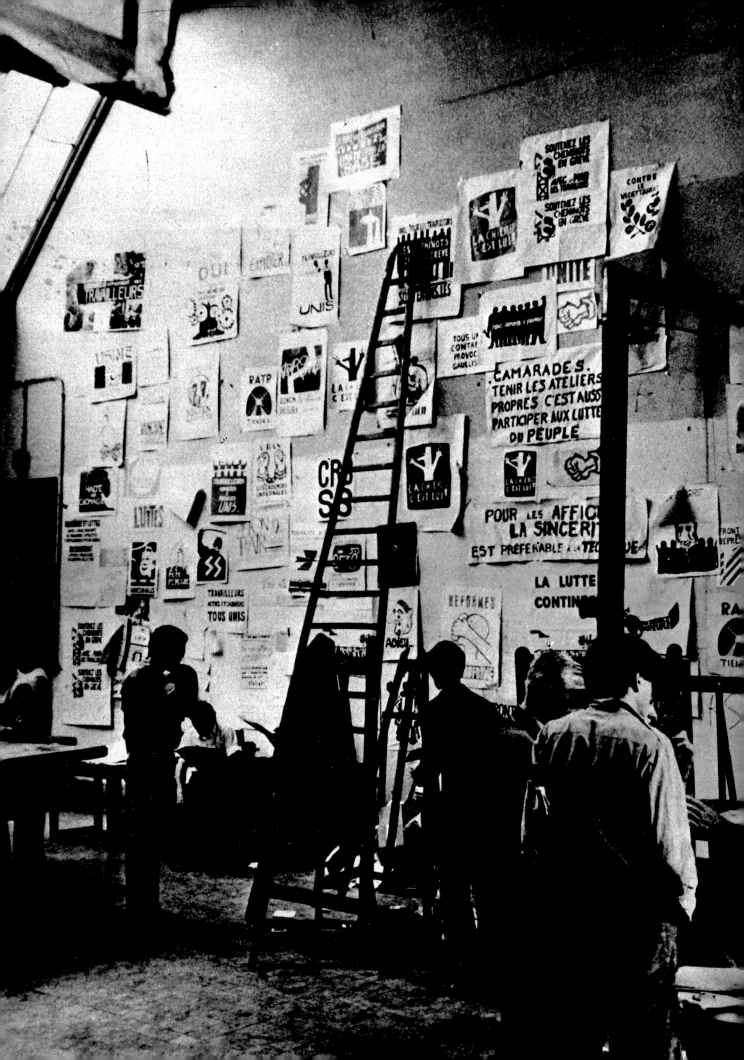

INTRODUCTION

Facing page:
Atelier Populaire posters
on display in Paris, 1968.
Source: *Posters from
the Revolution, Paris,
May 1968* (London, 1969)

Cover of *Świat* ('World'),
an illustrated weekly
published in Poland
showing posters
promoting the Polska
Zjednoczona Partia
Robotnicza (Polish
United Workers' Party).
March 1954.
Private Collection

The Cold War was fought on many fronts.
Rarely contested with 'hot' weapons, it was, in
many ways, a propaganda war in which images
were used to produce both fear and loyalty,
at home and abroad. The poster was a crucial
medium in this war of images, employed not
only by the superpowers to demonstrate their
economic, technical, cultural, moral and,
above all, ideological superiority, but also by
protest groups. Radicals on both sides of the
East–West divide seized the medium to broad-
cast their opposition to the Cold War order.
Posters were pasted on the walls of Moscow,
Paris, Berlin and Beijing at moments of electric
political tension.

This book surveys posters from the entire Cold
War period, from the late 1940s, when the
'Iron Curtain' was drawn across Europe, to the
collapse of communism in the Soviet Union in
the early 1990s. Some of the designs have been
selected for inclusion because they represent
powerful expressions by individual poster artists,
an articulation of their critical views on life in a
world ordered by Cold War divisions. Others
represent the viewpoint of states and political
groups motivated by ideology. The designs that
they commissioned may not necessarily meet
the highest standards of poster aesthetics,
but they mark important historical moments in
the decades after the Second World War. Some,
in fact, contain vicious images and menacing
sentiments. This aspect should not be down-
played: such designs were issued to produce
anxiety. Alongside these two categories of

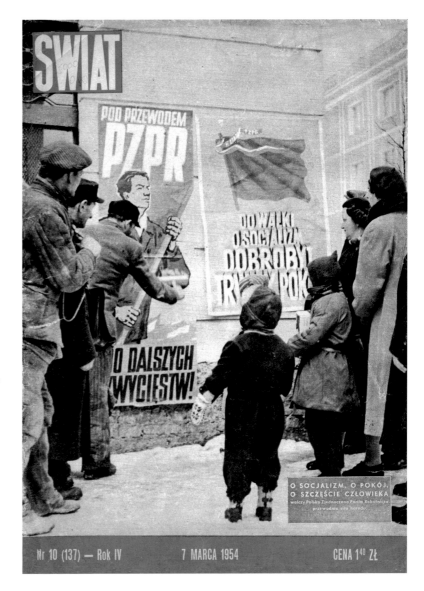

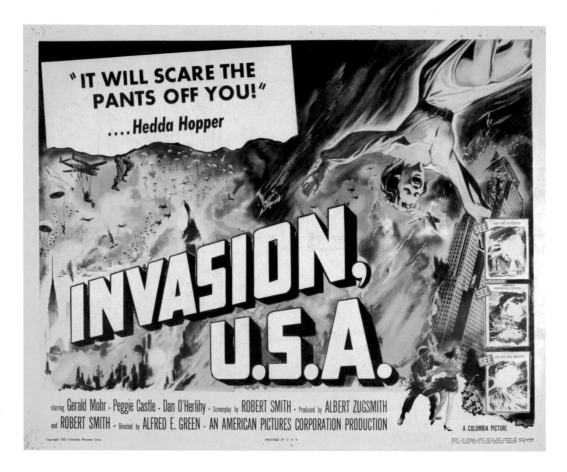

posters, a small selection of cinema posters is featured in this book. The movies were one of the crucial Cold War 'battlegrounds', particularly before the advent of mass television broadcasting in the West in the 1950s and in Eastern Europe in the 1960s. The Soviet ideologue Andrei Zhdanov made this clear at the outset of the Cold War freeze when he launched a campaign against the influence of America in Europe. One of his first targets was Hollywood film, which was almost entirely banned for almost a decade from Eastern European cinemas.

Like the poster, the movies provided powerful images of a conflict that was often conducted in secret. Spy planes, espionage, secret science cities in the East and West and the machinations of diplomats, as well as the terrifying image of a world destroyed by nuclear weapons, presented a kind of barrier to vision that could be overcome only by the imagination of artists, designers and film-makers. The cinema presented its viewers with the strange experience of finding pleasure in what they should have feared most. Consider, for instance, the B movie *Invasion USA* of 1952, a money-spinner for its maker, the

veteran director Alfred E. Green. An eccentric artefact of Cold War culture, this film is a blend of stock footage, staged newscasts and romantic melodrama. In the film the USA is invaded by an unnamed, but obviously Soviet, army. 'They push the button and vast cities disappear before your eyes' shrieks the film's publicity. And, on screen, Manhattan disappears under a great arching nuclear hemisphere of death.

In the spectrum of media technologies available to the states, groups and individuals who fought the Cold War, the poster was, perhaps, the least modern. In the 1960s, television pictures beamed by satellites circling the globe or broadcast from the surface of the moon represented the competing claims of Western capitalist states or Eastern Bloc societies over modernity. The development of the Internet — the dominant medium of our age — is a Cold War technology. It has a strange parentage, both in the decentralized computing networks created in America in the 1960s to permit military and government communication in the event of a nuclear attack and in the alternative technology projects that emerged in California in the late 1960s and '70s. In the world of

transistors and microchips, the medium of the poster would seem anachronistic. Two facts ensured its continued potency in the Cold War years. For individuals and small groups without access to electronic media, the poster presented a simple and available medium. When students occupied their universities in the 1960s, or the anti-communist underground engaged in samizdat (self-publishing) activities in Eastern Europe in the 1980s, posters were produced with simple screen-printing equipment in temporary locations. The poster could speak for groups that otherwise had no voice. For many radicals in the late 1960s, the poster could be an instrument for a new revolutionary society that threw off the conventions that kept Cold War societies locked together in mutual antagonism. In 1970 the media theorist Hans Magnus Enzensberger claimed, naively, that the posters — or what were known as *dazibao* (large character posters) — that were pasted on the walls of Chinese cities and villages during the Cultural Revolution of the second half of the 1960s were evidence of a new society in the making, in which ordinary people became authors of their history.[1] Here, he claimed, was an example of communication becoming properly a medium in which ideas were exchanged and not simply broadcast. The low-tech medium of print on the walls, he believed, had lessons for an electronic media that, as it was then organized, produced passivity.

Posters and new media like television did not necessarily represent different poles on the high-tech spectrum. In fact, they were folded into one another, with poster images drawing their source imagery from electronic media and, in turn, posters sometimes themselves drawing the attention of the world's press. For instance, one of the most emotive and striking images in this book is an anti-Vietnam War poster produced by the Art Workers Coalition in New York in 1970 (see pp.80–1), which comments on the massacre of Vietnamese citizens in the village of Mai Lai by a troop of US soldiers in 1968. It combines an official image taken by a US army photographer with a distressing admission made by one of the GI participants in a television interview that the troops had shot babies. The poster produced one of the most powerful indictments of American foreign policy. What is more, the artists returned this image back to its mass-media home by parading it for the world's media in front of Pablo Picasso's *Guernica* (1937), one of the most compelling anti-war images of the twentieth century, at the

Museum of Modern Art in New York in 1970. The best posters — like the best works of art — have the potential to crystallize an idea in a powerful image. An arresting poster — like István Orosz's demand for the Soviet forces to withdraw from Hungary after the collapse of communist rule in 1989 (see p.102) — could seem to tap and channel the sentiments of an entire nation. Such posters attract attention with their graphic force. F.H.K. Henrion's design promoting the cause of peace in the early 1960s, when the world seemed to be on the brink of a third world war, is a case in point (see p.73). But unlike artworks, posters appear in the everyday spaces of ordinary life. When encountered unexpectedly during the Cold War era they could seize attention in a way that television or cinema was never able to achieve.

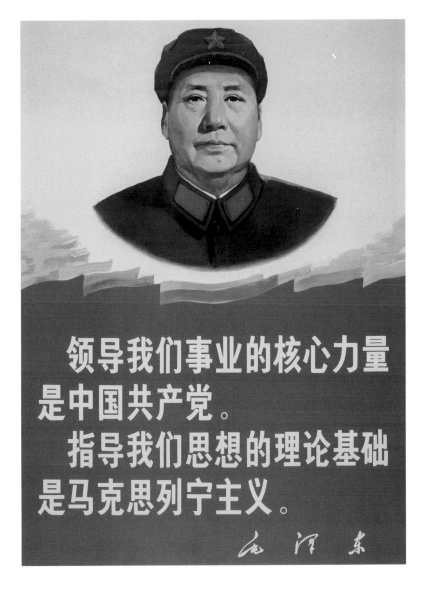

Unknown designer, *What Leads Us Is the Chinese Communist Party. What Guides Us Is Marxism and Leninism. Mao Zedong.* China, c.1966. V&A: E.686–2004

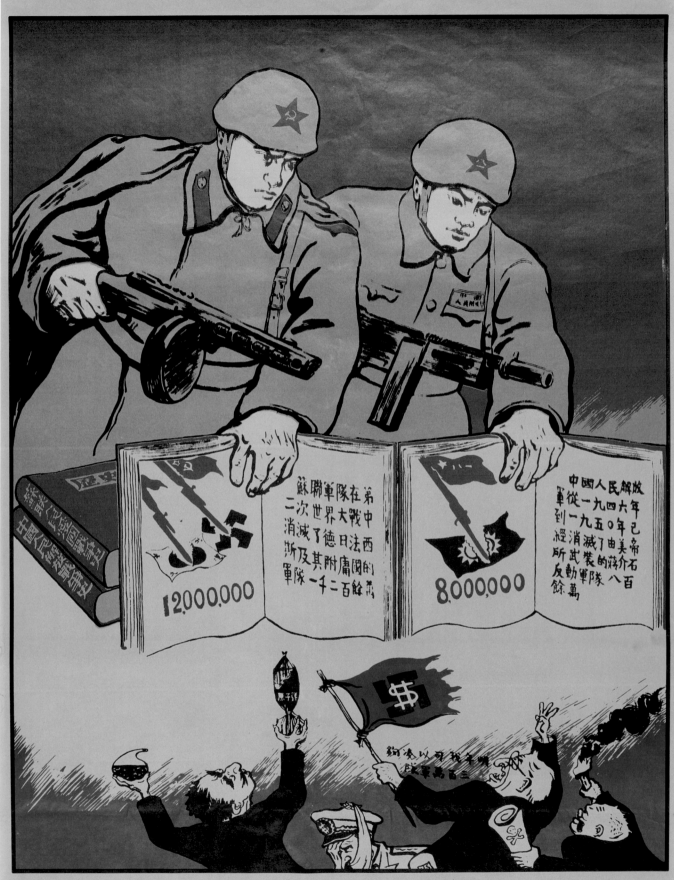

美國侵略者必敗

1

A WORLD DIVIDED

The Cold War was shaped by the intense rivalry between the United States of America and the Soviet Union, the two superpowers that emerged from the ruins of the Second World War. The world was divided within months of the end of the conflict into what Andrei Zhdanov described antagonistically as 'the imperialist and anti-democratic camp, on the one hand, and the anti-imperialist and democratic camp, on the other'.[2] At the same time Western statesmen were keen critics of the Soviet occupation of Eastern Europe. Winston Churchill, speaking in the USA in 1946, described life in Eastern Europe as being in the shadow of an 'Iron Curtain'. For the forty years that followed, much of the world was divided on Cold War lines (with a few nations, like Yugoslavia, asserting their non-aligned status). Alliances and treaty organizations such as NATO (the North Atlantic Treaty Organization formed by the USA and Western European states in 1949) and COMECON (Council for Mutual Economic Assistance, also established in 1949, which bound Eastern European states into the Soviet economy) turned alliances into 'blocs'. The declaration of the People's Republic of China in 1949, a new ally of the Soviet Union, added considerably to the sense of communism's

march on the world. Much American money and effort were spent trying to contain its spread around the world in the years that followed. The superpowers never engaged each other in direct hostilities, but the Cold War did produce many victims, particularly in the developing world, where East confronted West through its proxies. The Korean War, the Vietnam War, Central American revolutions and counter-revolutions, as well as civil wars in Africa, were all catalysed by Cold War antipathies and often sponsored with dollars and roubles.

Images were central to the Cold War conflict. Each side made considerable ideological investment in representing its own actions and interests as benign and those of the other as selfish and menacing. The East was not, however, a mirror image of the West: in the liberal, free-market societies of the West, freedom of speech was consecrated as a fundamental right. This meant that anti-capitalist protestors or critics of American foreign policy were able to express views in ways denied to their anti-Soviet contemporaries in the East. The wave of American consumer goods and popular culture that crossed the Atlantic in the 1950s, for instance, provoked the wrath of the European

Facing page:
Monumental figures symbolizing the People's Liberation Army and the Red Army express their authority by asserting their ability to defeat their enemies before the leaders of the West. China, 1951.
Private Collection

Left. In France the communist poet Louis Aragon thundered against the symbol of Americanization:

> A Ford automobile, the civilisation of Detroit, the assembly line … the atomic danger, encircled by napalm … here is the symbol of this subjugation for the dollar, applauded even in the land of Molière: here is the white lacquered god of foreign industry, the Atlantic totem that chases away French glories with Marshall plan stocks … The Yankee, more arrogant than the Nazi iconoclast, substitutes the machine for the poet, Coca-cola for poetry, American advertising for the *la Légende des siècles*, the mass manufactured car for the genius, the Ford for Victor Hugo.[3]

Whilst the Cold War rarely tipped into violence in Europe, the stakes were very real. Berlin, for instance, was a persistent hot spot. The division of the city between the Allies at the end of the Second World War meant that East faced West in a literal sense. The Kremlin attempted to force the Western powers to withdraw from the city in 1948 by cutting off road and train access, and therefore the supply of food and fuel. The Western allies mounted an enormous airlift of supplies to the city until Stalin backed down in the summer of 1949. Just over ten years later tensions rose again: in August 1961, with East Germany haemorrhaging people (more than 200,000 had left the country for the West in the first seven months of the year), the communist leader Walter Ulbricht ordered the building of an 'anti-fascist protection barrier'. The Berlin Wall became the Cold War's most notorious symbol of division, with more than 100 people killed trying to cross it before it was dismantled in 1989.

Even during the periods of relative calm, Berlin remained a site of competition in other ways. East German television viewers in the 1960s and '70s, for instance, were able to tune into Western television signals, which provided both a perspective on the growing affluence of West Germans enjoying the benefits of the *Wirtschaftswunder* (economic miracle) and information on world affairs denied by the censors. Unable or unwilling to block television reception, the East German authorities invested considerable energy in dismissing the news and images of everyday life tapped by East German rooftop antennae. A notorious weekly television programme, *Der schwarze Kanal* ('The Black Channel'), was broadcast from 1960 (before the Berlin Wall was erected) by the state broadcaster. Playing clips of West German

Unknown designer,
One Small Step for Man,
poster issued by NASA
to record the *Apollo 11*
landing on the moon.
USA, *c*.1970.
V&A: E.1967–2004

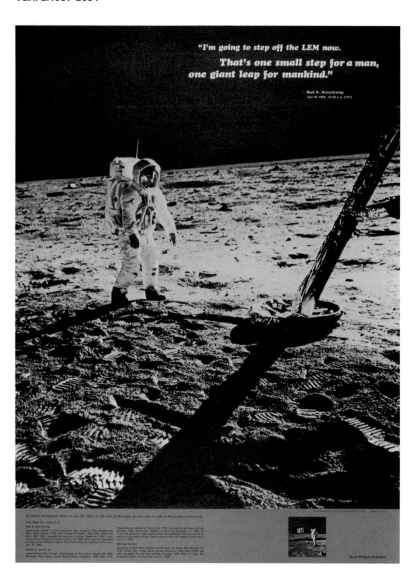

television with a disparaging commentary, the East German authorities set out to reveal the 'lies' and 'errors' they contained.

The Cold War superpowers each claimed a superior hold on the future. Marxist-Leninism provided the Eastern Bloc with a clear claim on its pre-eminence: according to its logic, socialism was an advanced form of society that, if properly managed, would lead to the nirvana of full communism. Capitalism, too, had an inbuilt faith in progress, with its attachment to the fashion system, the freedom of consumers to pursue affluence and 'virtuous' cycles of economic growth. Cold War rivalry was not just a matter of political rhetoric: it also stimulated real advances in the development of technology, many of which found their ways into everyday applications. The development of microwave technology, the laser and the Internet were all accelerated by Cold War competition.

The most dramatic sphere of technological competition was the Space Race. The USA and the USSR chased each other into space during the course of the 1950s and '60s. The launch of the first man-made object in space, *Sputnik 1*, in 1957; the first manned space flight by the cosmonaut Yuri Gagarin in 1961; and then the moon landing by *Apollo 11* astronauts Neil Armstrong and Buzz Aldrin in 1969 were remarkable human achievements. It is impossible to disentangle the military 'benefits' of the Space Race from the ideological ones. One of Armstrong's first actions as he stepped onto the dusty surface of the moon was to turn on a television camera that beamed pictures of the American triumph back to earth. The USA made a strong point of eschewing any territorial ambitions on the moon, claiming it in the name of mankind. But the point was clear: America had outdone its rival.

The lunar landing changed people's consciousness of mankind and of its home, the earth. During NASA's *Apollo 8* mission to map the surface of the moon for possible landing sites in 1968, the astronauts on board captured one of the most widely reproduced images of the century, 'Earthrise', the view of the earth as if seen from the surface of the moon. The contrast between the luminous and indisputably living surface of the blue planet swathed in clouds and the dusty surface of its satellite prompted a wave of sentiment, with commentators stressing the fragility of the earth in an age when milita-

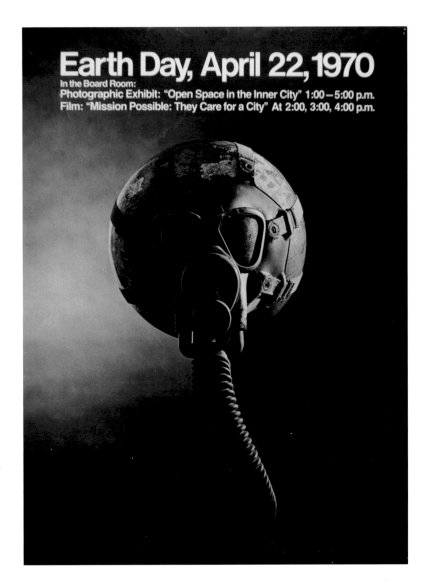

rism and affluence, twin buttresses of the Cold War order, prevailed. The protective atmospheric layer that supported life on earth was evidently thin when compared with the dark vacuum of endless space. One had only to look at the dead surface of the moon to realize this. Others pointed to an image of the planet that was not inscribed with borders or political divisions. Africa, a 'forgotten' continent conventionally reduced in scale by the Mercator projection used to represent the globe on 2-d maps, loomed much larger than many had imagined it. The American counter-culture activist Michael Shamberg wrote: 'It's ironic that NASA, probably the greatest government agency produced by America, has killed patriotism. National boundaries are simply not a motivating image when we have photographs of the Whole Earth.'[4] In this Cold War image there lay, for some, the possibility of discovering a new and just world.

Robert Leydenfrost, poster to promote Earth Day events. USA, 1970. Photograph by Don Brewster. V&A: E.329–2004

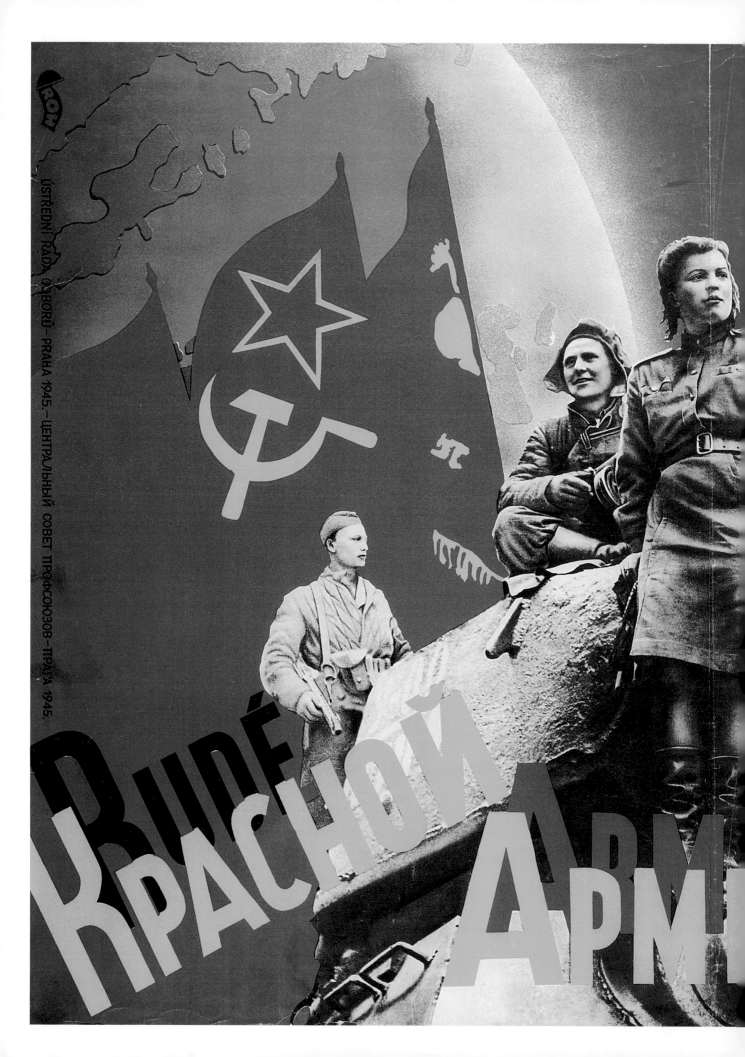

ÚSTŘEDNÍ RADA ODBORŮ – PRAHA 1945. – ЦЕНТРАЛЬНЫЙ СОВЕТ ПРОФСОЮЗОВ – ПРАГА 1945.

Rudé Красной Арми

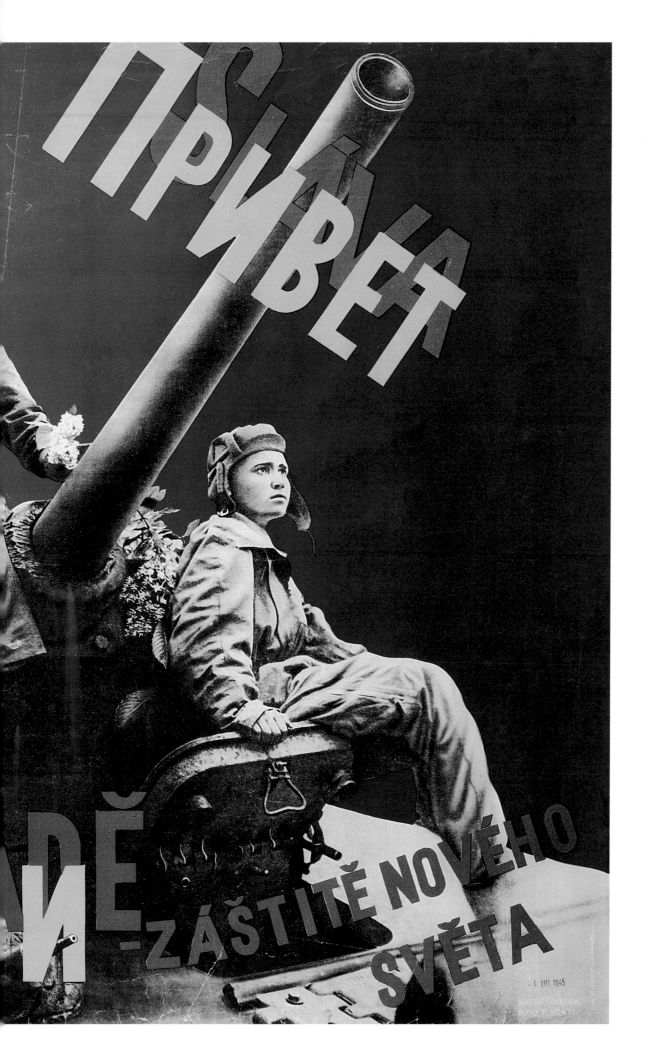

WELCOME TO
THE LIBERATORS

When the Red Army liberated Prague in May 1945, many Czechs welcomed the arrival of the Soviet forces, not only as the liberators of the nation from the brutal Nazi regime but also as the harbingers of a social revolution. Karel Šourek's poster greeted the arrival of Stalin's forces with a ringing slogan, printed in both Czech and Russian: 'The Glory of the Red Army Guarantees a New World'. Soviet troops are represented as an irresistible force that will sweep away reaction and paint the globe red.

In its dynamic layout and use of montage, Šourek's design demonstrates a familiarity with the modernist posters produced by artists like Alexander Rodchenko in Russia in the 1920s. Produced before the imposition of Socialist Realist aesthetics on the Eastern Bloc in the late 1940s, Šourek's design represented the short-lived hope in the possibility of a revival of avant-garde design in a new socialist Czechoslovakia.

THE BLACK MARKET
DESTROYS PEACE

Life in Europe after 1945 was harsh and, for many, perilous. Millions of displaced people, the destruction of entire cities and the collapse of economic life created conditions in which the black market thrived. The underground trade in medicines presented a particular problem for post-war governments (and was the theme of Carol Reed's powerful film noir *The Third Man* of 1949, which was based on the hunt for black marketer Harry Lime, peddling adulterated penicillin in post-war Vienna).

Thole's design for the Dutch National Information Service makes a direct connection between the ruined economy and the prospects of social security. A white dove — the archetypal symbol of peace — is injected with black-market medicine with fatal consequences.

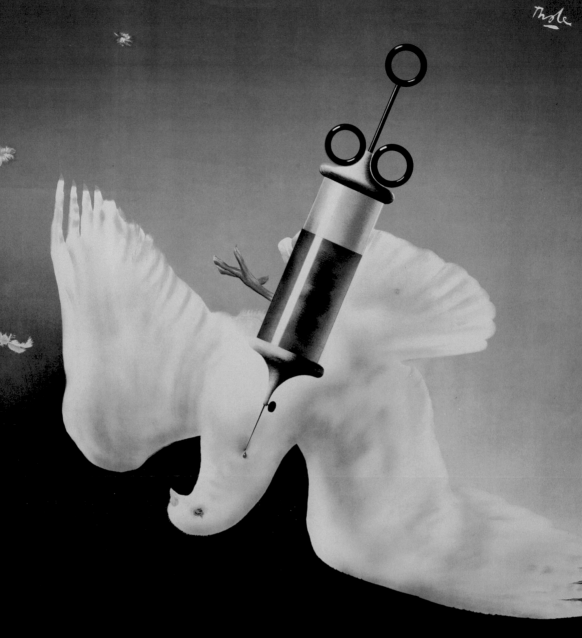

GIFHANDEL
VERGALT DEN VREDE

PUBLICATIE REGEERINGSVOORLICHTINGSDIENST

Facing page:
Max Bill, *USA baut*
('USA Builds'),
poster promoting an
exhibition at the
Kunstgewerbemuseum,
Zurich. Switzerland,
1945. V&A: E.217–1982

Below: Detail

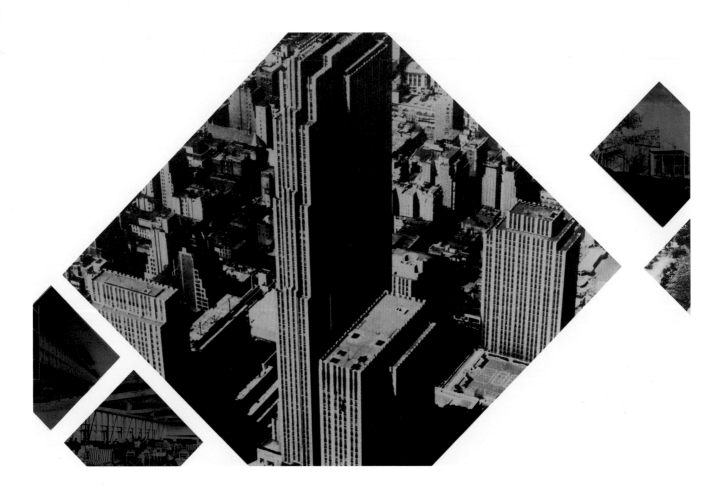

THE USA BUILDS

The *USA Builds* exhibition held in the Applied Arts Museum in Zurich just after the end of the Second World War was an early example of what was to become a major sphere of cultural exchange in the 1940s and '50s. The USA invested considerable energy into promoting its culture in Europe, particularly after the announcement of the Marshall Plan in 1947 and the Cold War freeze in international relations of the late 1940s.

Designed by Max Bill, this poster represents a meeting of the European and American species of modernism. The Swiss painter, sculptor and graphic artist was the leading exponent of Concrete Art, a form of abstract art that eschewed symbolism or reference to the real world, which was to grow in influence in the post-war period. A language of art based on the abstract forms of lines, planes and flat fields of colour was highly appealing to a post-war generation in Central Europe who had seen art conscripted into propaganda by the Nazis and the Soviets in the 1930s. At the same time, the images that fill the rhombuses in Bill's design include New York skyscrapers and highways, archetypal expressions of American modernity.

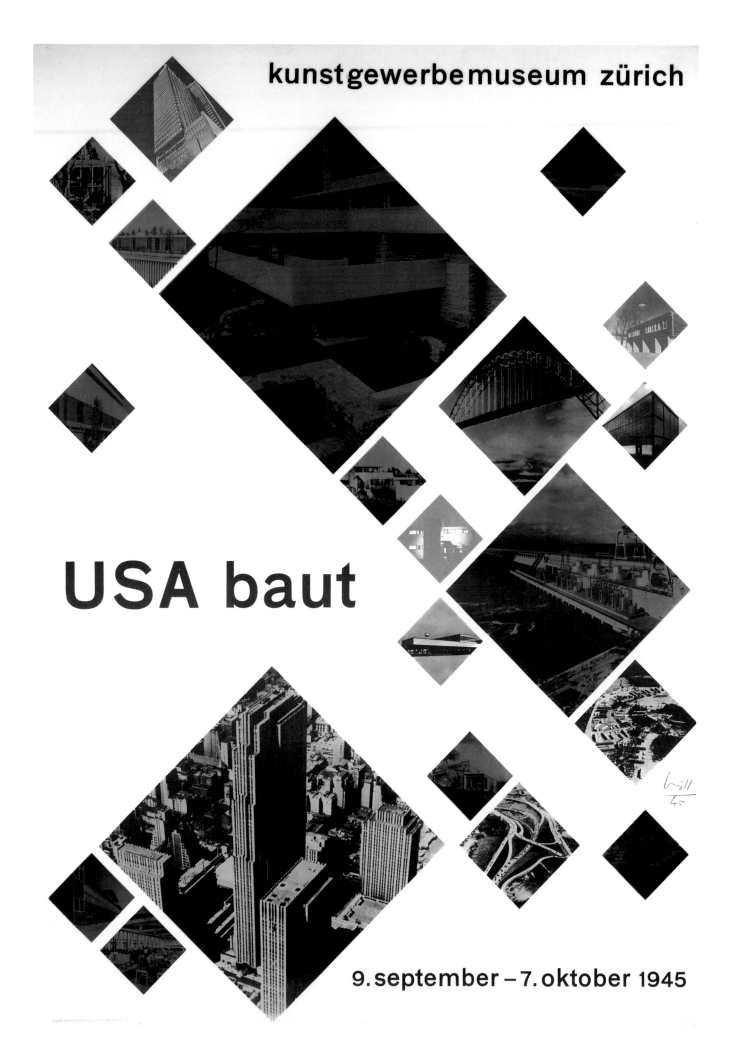

THE MARSHALL PLAN

The Marshall Plan for reconstruction in Europe was produced in response to the grave situation there in 1946–7, when the fear of starvation and social unrest was very real. Announced by President Truman's Secretary of State George C. Marshall, it was not just a programme of aid for the devastated countries of Europe, but also a way of inhibiting the spread of communism across the continent. Eastern European states in Moscow's 'sphere of influence' were invited to benefit from the programme, but the Kremlin denied them the opportunity. The Soviet press explained: 'these countries and people … refuse to trade their national independence, preferring to build up their own industries rather than … [accept] American handouts'. The designer Gaston van den Eynde drew on a simple metaphor to express the purpose of the plan in his poster of 1950, representing it as a solid wooden stake supporting a young blossoming tree.

Gaston van den Eynde,
Par Le plan Marshall coopération inter-européenne pour un niveau de vie plus élevé **('European Co-operation for a Higher Standard of Living with the Marshall Plan'). 1950. V&A: E.1900–1952**

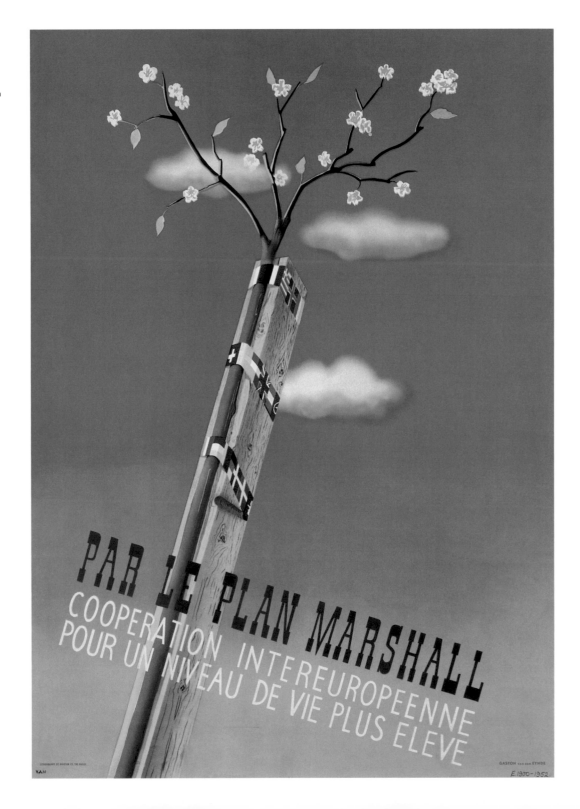

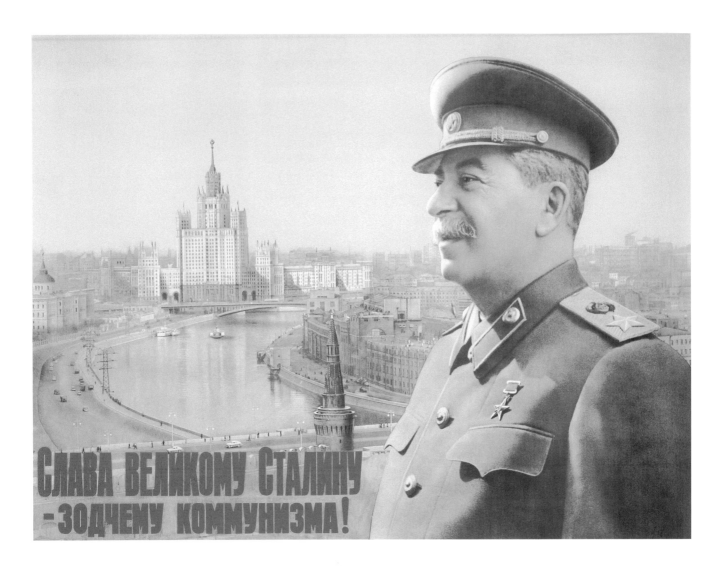

'THE GREAT STALIN'

In the cult of personality that enveloped Stalin in the Soviet Union, the designer had to obey a clear set of rules. The Soviet leader was to be represented as a kind of colossus amongst men and as a figure of boundless vision and compassion. Petrov's montage for this poster of 1952 followed convention by placing an image of the *generalissimo* before the Moscow cityscape with his eyes fixed on the horizon. The view is filled with the Ukraine Hotel, one of a chain of Soviet skyscrapers built in the city to commemorate Moscow's eighth centenary. Ultimately — as Petrov's design made clear — they were public monuments to the 'genius of world history', Stalin himself.

N. Petrov, *Glory to the Great Stalin, the Architect of Communism.* Soviet Union, 1952. Private Collection

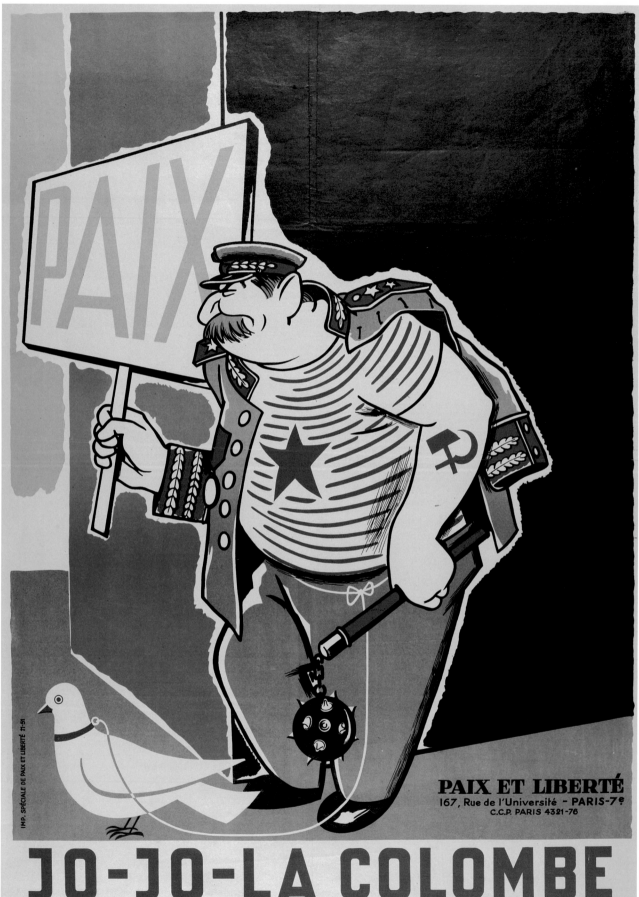

JO-JO-LA COLOMBE

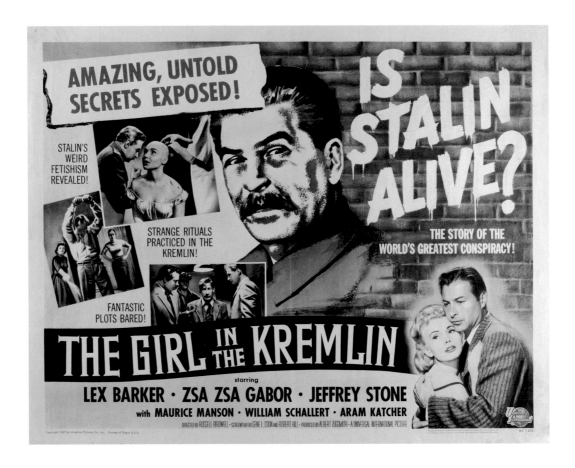

STALIN IN THE FRAME

Paix et Liberté was an anti-communist group in France that took up the cause of human rights in the Soviet Union. It was formed in response to the Stockholm Appeal of 1950, which called for a complete ban on nuclear weapons, initiated by the atomic scientist Frédéric Joliot-Curie. The figure of Stalin became a particular target, and his declaration of peaceful values was identified as empty rhetoric. In this poster of 1951 issued by Paix et Liberté, he is represented as a peace campaigner with dark intentions.

Even after his death in March 1953, the Soviet leader seemed to haunt the Cold War consciousness. *The Girl in the Kremlin*, a B-movie exercise in kitsch made in 1957, was based on a combination of rumours circulating that Stalin had been a rapist and that his death had been faked. The plot of the low-budget thriller, staring Zsa Zsa Gabor, was based on the conceit that a double had taken Stalin's place at his funeral. The dictator was now living in luxury in Greece. A secret service agent is hired to extract a young woman from his clutches.

AMERICAN 'DEMOCRACY'

The field of human rights was a crucial sphere of Cold War contest. American politicians harangued the Kremlin for its suppression of freedom of speech and for jamming western radio broadcasts, as well as for its network of prisons and gulags; Soviet ideologues in the 1950s and early 1960s attacked America for the racial discrimination endured by African-Americans. This Viktor Koretzky poster combined the symbol of American freedom, the Statue of Liberty, with a scene of licensed brutality. A group of uniformed officials — perhaps police officers — appear to be lynching a black man, a fate suggested by the ominous presence of a noose. The poster was produced for Soviet consumption. In the course of the 1960s Soviet ideologues frequently invoked racial injustice in the USA on the international stage in order to capture the support of the developing world.

Facing page:
Viktor Koretzky,
The Shameful Brand of American 'Democracy'.
USSR, 1963.
V&A: E.1739–2004

Left: Detail

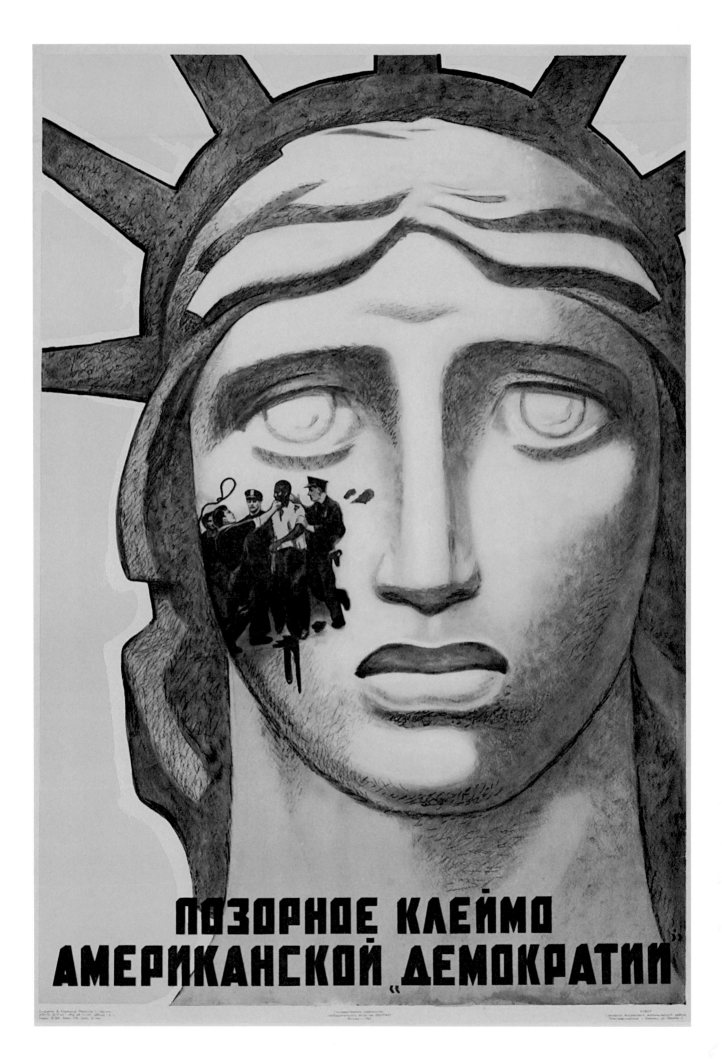

ПОЗОРНОЕ КЛЕЙМО
АМЕРИКАНСКОЙ „ДЕМОКРАТИИ"

IT'S HAPPENING AS YOU READ THIS!

ESCAPE FROM EAST BERLIN

ACTUALLY FILMED WHERE IT HAPPENED!

From METRO-GOLDWYN-MAYER

Starring

DON MURRAY · CHRISTINE KAUFMAN

Screen Play by GABRIELLE UPTON, PETER BERNEIS and MILLARD LAMPELL · Story by GABRIELLE UPTON PETER BERNEIS · Directed by ROBERT SIODMAK

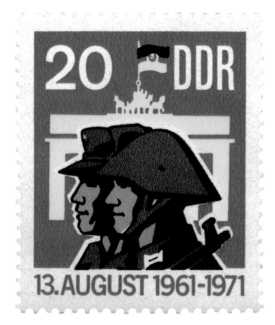
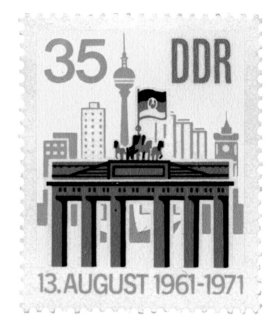

ESCAPE FROM EAST BERLIN

In 1961 the East German communist leader Walter Ulbricht erected what he called the 'Anti-Fascist protection barrier', better known to the rest of the world as the Berlin Wall. His aim was to stem the tide of people fleeing East Germany for life in the West, as well as the streams of Western goods crossing into the Democratic Republic of Germany. The wall was in some ways a misnomer: it formed an international border complete with barbed wire, minefields and watchtowers.

With families divided and people prepared to risk their lives to cross it, the Berlin Wall became the most powerful icon of the human costs of the Cold War.

The wall entered into popular culture very rapidly. Espionage films such as *The Spy Who Came in from the Cold* (1965), starring Richard Burton, used the wall as a backdrop. Robert Siodmak's film of 1962, *Escape from East Berlin*, was one of the first movies to explore the effects of division on ordinary lives. The film was part-melodrama, part-thriller, but the poster's designer nevertheless chose to emphasize its topicality in the banner headlines that emerge from the symbolic red background.

East German postage stamps commemorating the tenth anniversary of the construction of the Berlin Wall. East Germany, 1971. Private Collection

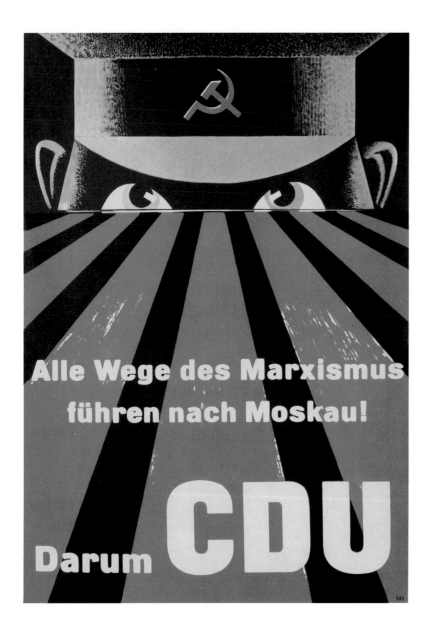

Facing page:
Unknown designer,
*Chrustschew Fordert:
Stürtzt Adenauer nun erst
recht CDU* (Khrushchev
calls 'overthrow
Adenauer. Now more
than ever', CDU).
West Germany, late
1950s / early 1960s.
Private Collection

KHRUSHCHEV'S GRIP ON BERLIN

Unknown designer, *Alle
Wege des Marxismus
führen nach Moskau!
Darum CDU* ('All Marxist
Ways Lead to Moscow!
Therefore CDU'), poster
for the Christlich
Demokratische Union.
West Germany, 1953.
Private Collection

West Germany felt itself to be the target of Soviet interests during the 1950s and '60s. These posters were produced for the Christian Democratic Union (Christlich Demokratische Union Deutschlands / CDU), a centre-right political party, in the 1950s. They represent the CDU's long-standing suspicion of Moscow. Under Konrad Adenauer, the first Chancellor of the Federal Republic of Germany, the CDU sought to achieve West German sovereignty by integrating it firmly into the West. He was suspicious of Soviet promises made in the early 1950s to unify the two Germanies, detecting the threat of further Sovietization in such offers. Even when Premier Khrushchev took the reins of power in the Kremlin and engaged the West in what he called 'peaceful competition', Soviet attitudes to West Berlin remained belligerent. In November 1958 Khrushchev gave the Western powers six months to agree to withdraw from West Berlin and make it a free, demilitarized city. Notoriously, he described the city as 'the testicles of the West', which he held in his iron grip.[5] The CDU poster designer amplified what many in West Germany took to be the Soviet leader's unhinged behaviour by accentuating the tonal contrast in this photograph. Cast in shadow, Khrushchev's eyes seem demonic.

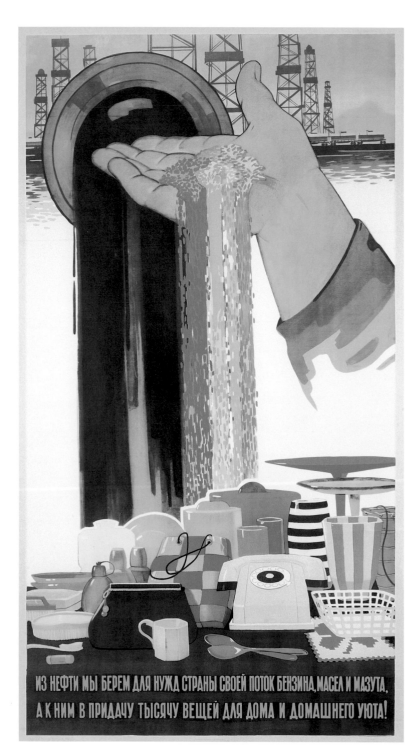

Viktor Koretzky,
From Oil We Take for the Needs of
the Country Gasoline, Petrol and Oils and
On Top of That Thousands of Other
Things for the House and Domestic Comfort.
USSR, 1960. Private Collection

THE NEEDS
OF THE COUNTRY

In the late 1950s the Soviet leadership engaged the West on new Cold War fronts. In numerous loudly voiced declarations, the Soviet leader Nikita Khrushchev announced that the standard of living in the Soviet Union would surpass that in the USA by 1980. After the Stalin years, when consumption had been depressed in order to maintain high levels of industrial production, the new regime sought to claim legitimacy by addressing the problem of shortages. Synthetic materials such as plastic were viewed as a way not only of rapidly expanding the capacity of Soviet industry, but also of creating an efficient and rational environment for socialist lives. Viktor Koretzky's poster from the early 1960s trumpets this change of priorities. This policy was also an echo of an ironic contribution to the Cold War by the American sociologist David Riesman that he called 'Operation Abundance'. In 1951 he argued that Americans should conduct a 'Nylon War' with the Soviet Union, in which its citizen comrades would be bombarded with consumer goods rather than weaponry.[6] Their appetites to consume would have a far greater effect on the course taken by the Soviet Union than any other American action. Riesman's ironic fable was prophetic: ultimately, Soviet attempts to compete with capitalism in the sphere of consumer goods were largely unsuccessful, arousing desires that it was ill equipped to fulfil.

THE IPCRESS FILE

Sidney J. Furie's film of 1965 provided the viewing public with vivid images of one of the most secret aspects of Cold War competition, espionage. The central theme of the movie, adapted from Len Deighton's novel of 1962, concerns brainwashing. Like a CIA cryptonym, IPCRESS stands for 'Induction of Psycho-neuroses by Conditioned Reflex under strESS'. In the West, public anxiety about brainwashing was triggered by dramatic reports about Chinese and North Korean use of mind-control techniques on US prisoners of war in Korea, and Soviet experiments on anti-communists in Central Europe. In its use of dramatic quotes drawn from the press, this poster stresses the film's gritty realism, an antidote to the glamour image of espionage promoted by the James Bond films.

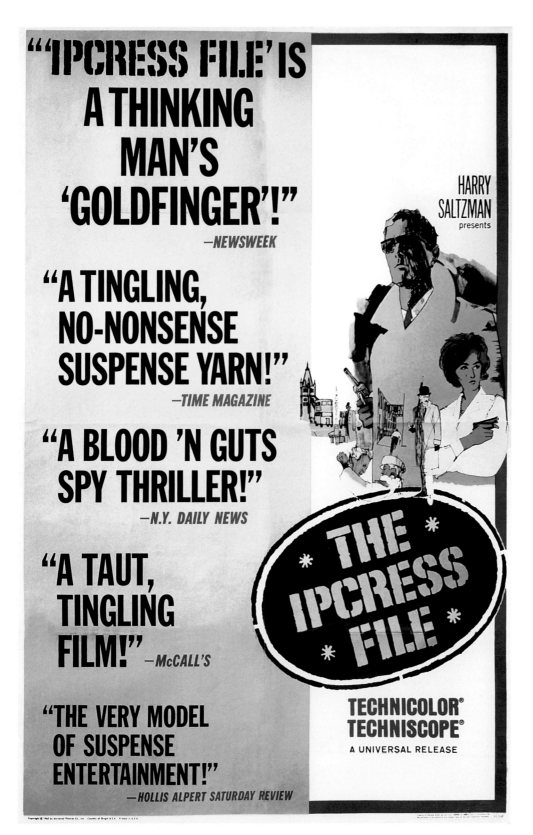

Unknown designer,
The IPCRESS File.
Universal Studios, 1965.
Private Collection

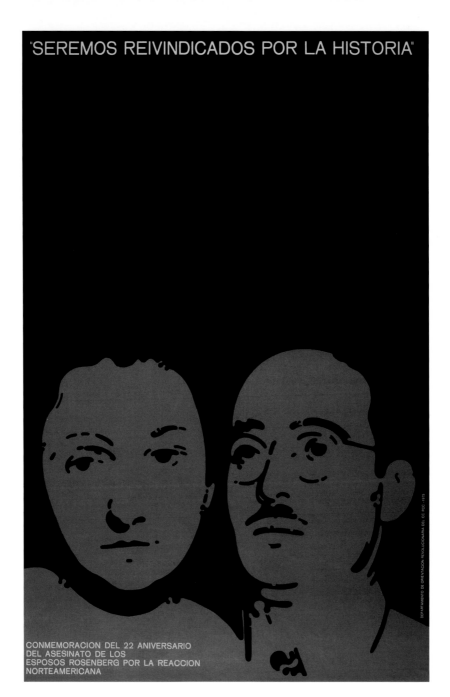

"SEREMOS REIVINDICADOS POR LA HISTORIA"

CONMEMORACION DEL 22 ANIVERSARIO
DEL ASESINATO DE LOS
ESPOSOS ROSENBERG POR LA REACCION
NORTEAMERICANA

E. Félix Beltrán, *Seremos reivindicados por la historia* ('We Will be Vindicated by History'). Cuba, 1975. V&A: E.1220–2004

ETHEL AND JULIUS ROSENBERG

The spy was a central figure in the iconography of the Cold War. The idea of fifth columnists at work destabilizing the 'American way of life' (or, conversely, dividing the 'brotherhood of working peoples' in the East) was an effective way of keeping societies on a Cold War edge. In 1953 the American communists Ethel and Julius Rosenberg were executed for passing classified information relating to the country's nuclear bomb programme to Stalin's Soviet Union. Reviled in the USA for accelerating the Soviet Union's nuclear weapon programme and, in the words of the prosecuting judge, for altering 'the course of history to the disadvantage of our country', they were hailed by communists throughout the world as martyrs for the cause. The French philosopher Jean-Paul Sartre, for instance, called their execution a legal lynching.[7] This poster of 1975 designed by Félix Beltrán was published in Cuba to commemorate their execution. It includes the words 'We will be vindicated by history', apparently written by Ethel Rosenberg before her death.

DON'T BRAG
ABOUT YOUR JOB

Although Western democratic states largely withdrew from the production of explicit graphic political propaganda after the Second World War, a small number of posters from the Cold War period can be found. This poster, for display in government and military offices dealing with 'sensitive' material, reminded employees of the interest that Britain's enemies might have in this information. Whilst not explicitly anti-communist, it drew on the fear of infiltration and espionage that fuelled Cold War paranoia and East–West enmity.

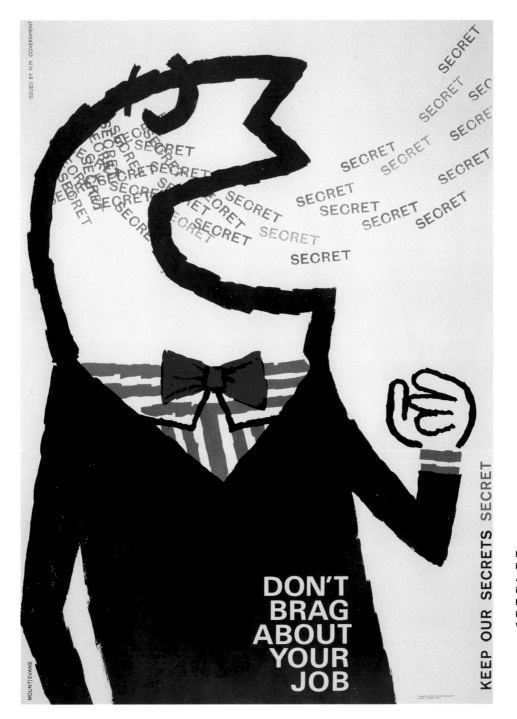

Reginald Mount and Eileen Evans, *Don't Brag About Your Job*, a public information poster issued by the Central Office of Information. UK, *c*.1960. V&A: E.211–1982

FIRST SPACESHIP ON VENUS

In many science fiction films of the Cold War period the cosmos is represented as an extra-terrestrial space in which international rivalries have been overcome. *Der Schweigende Stern* ('The Silent Star') of 1960 depicted a world in which communism had swept the planet and mankind enjoyed the benefits of nuclear technology and socialist fraternity. Internationalism was not only the theme but also the method of this movie: it was based on a book by the Polish science fiction writer Stanisław Lem and shot in East Germany with an international cast.

A threat to this peaceful utopia comes in the form of a mysterious object that contains a coded message threatening the Earth's destruction. A spaceship is dispatched to Venus, the source of this message. There, the international crew find the ruins of a warlike civilization that had itself already perished in a nuclear civil war. The Cold War message was clear to all.

The film was distributed in America under the title *First Spaceship in Venus*. Its communist theme was less important there than its capacity to satisfy the tremendous popular demand for science fiction.

East German publicity material for the DEFA film *Der Schweigende Stern*. East Germany, 1960. Private Collection

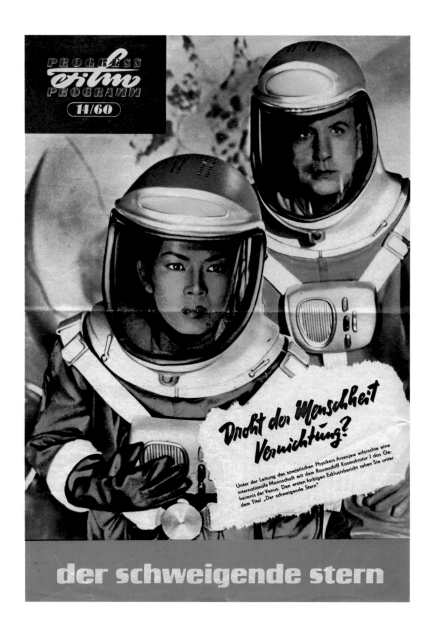

Facing page: Unknown designer, *Raumschiff Venus antwortet nicht* ('No Response from Spaceship Venus'). West German poster promoting the East German film *Der Schweigende Stern* ('The Silent Star'). 1960. Private Collection

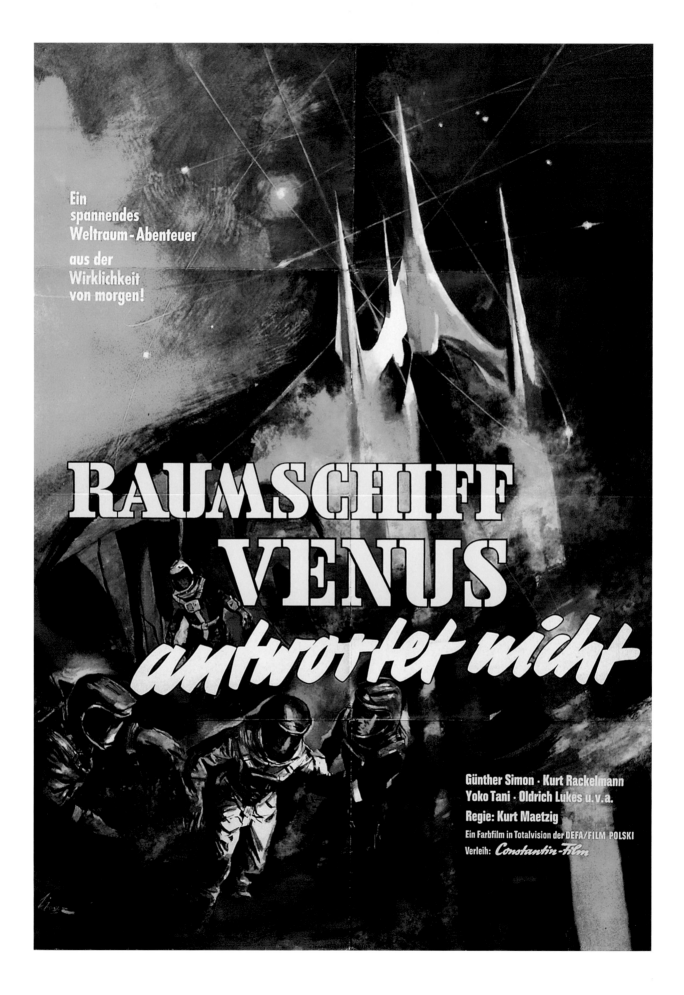

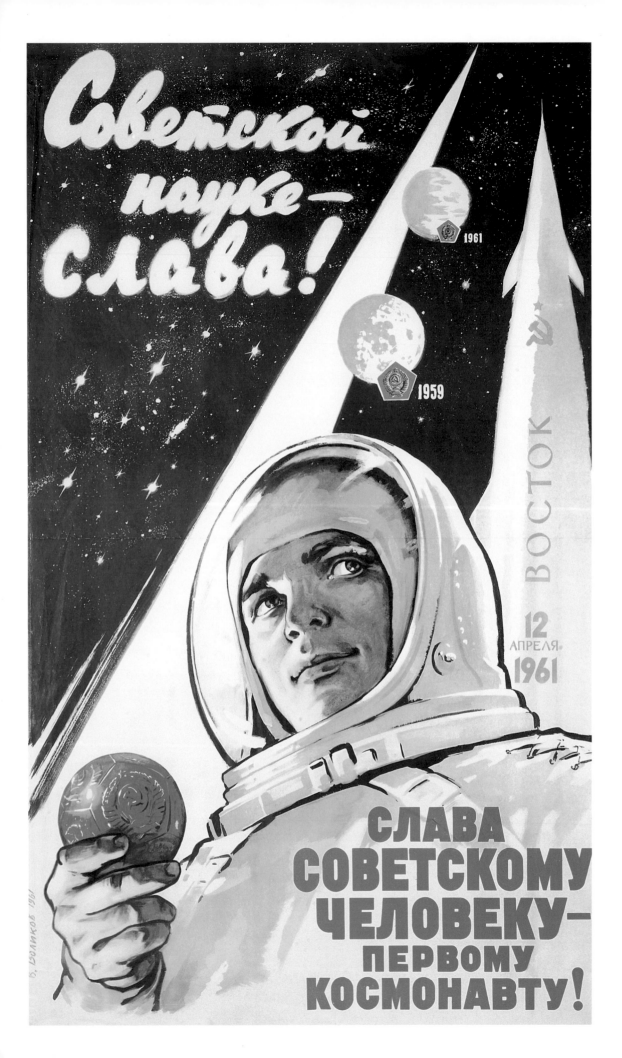

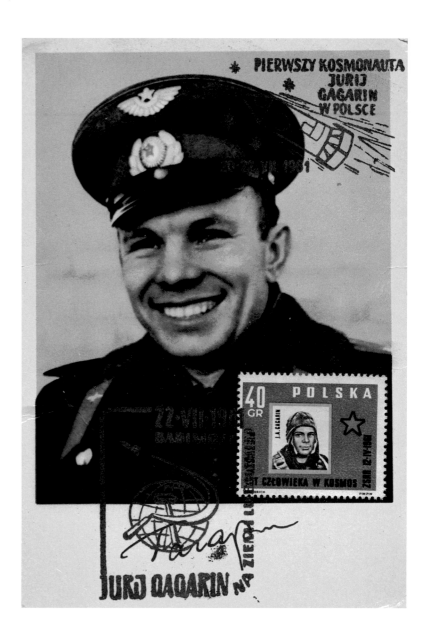

GLORY TO SOVIET MAN

In the late 1950s and early 1960s the Soviet space programme achieved a remarkable set of triumphs in the Space Race. The launch of the first satellite, *Sputnik 1*, in October 1957 was followed by sending the first animal into orbit, a dog called Laika, on *Sputnik 2* in November 1957. The first probes were sent to Mars and Venus in 1960 and 1961. The most stunning culmination of these remarkable achievements

was the first manned space flight by Yuri Gagarin on *Vostok 1* in April 1961. This son of Soviet peasants became the chief symbol of claims for the superiority of socialism over capitalism and the march of the Soviet Union towards communism.

Vadim Petrovich Volikov's poster depicts the first Soviet cosmonaut as a monumental figure flanked by the *Vostok* rocket inscribed with the symbolic date of 1961. The red sphere in Gagarin's hand perhaps represents the planet's future as a communist world without national, social or class divisions.

Postcard containing a commemorative stamp celebrating Gagarin's historic flight. Poland, 1961. Private Collection

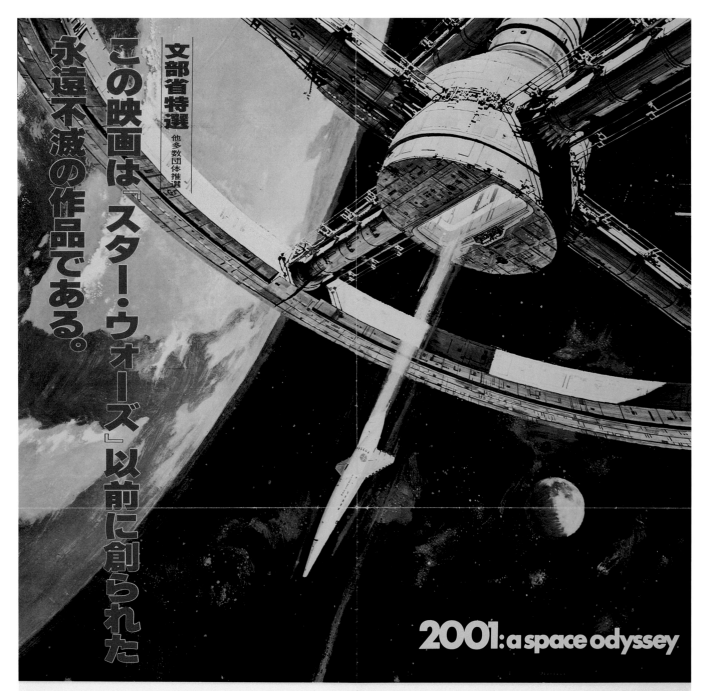

この映画は『スター・ウォーズ』以前に創られた永遠不滅の作品である。

文部省特選 他多数団体推選

2001: a space odyssey

『スター・ウォーズ』のジョージ・ルーカス監督は『2001年宇宙の旅』について言う。

スタンリー・キューブリックは究極的なSF映画を創った。そして、どんな人でもこれ以上の映画を製作することは非常に困難なことであろう。
技術的に比較することは出来るが私は『2001年宇宙の旅』が遥かに優れていると思う。

製作・監督スタンリー・キューブリック

2001年宇宙の旅

〈カラー作品〉

脚本スタンリー・キューブリック/アーサー・C・クラーク ■原作邦訳(早川書房刊)サントラ盤(MGMレコード)

主演キア・デュリア/ゲーリー・ロックウッド MGM映画 ㊙CIC配給 ③

映倫

2001:
A SPACE ODYSSEY

This poster — produced in Japan in 1978 to promote the reissue of Stanley Kubrick's film *2001: A Space Odyssey* (1968) — exploits Robert McCall's brilliant artwork. Entitled *Orion Leaving Space Station*, the painting depicts the departure of a space capsule from a massive wheel-shaped space station. Like Kubrick's film, McCall's image captures the sublime effects of technology in the endless vacuum of space.

Facing page:
Robert McCall,
***2001: A Space Odyssey*,**
film poster. Japan, 1978.
Private Collection

McCall had established a career as an illustrator for leading American illustrated magazines, *Life*, *Saturday Evening Post* and *Popular Science*, in the 1950s. Invited by NASA to record its operations, he produced insightful documentary images of the daily training routines of the astronauts, as well as the drama of launch-pad blast-offs and ocean landings. At the same time, McCall created powerful futuristic images for the popular weeklies to satisfy the widespread interest in the cosmos. His vivid realism resulted in compelling images of space travel in distant solar systems and man's colonization of other planets. They attracted the attention of Kubrick, who invited McCall to produce the designs for the posters promoting his visionary film.

SOLARIS

This poster to promote Andrei Tarkovsky's film *Solaris* (1972) was designed by Yuri Tsarev for the Soviet export film agency and overprinted by the Spanish distributor for its release there. Tsarev's image of the American astronaut Kris Kelvin holding the body of his dead wife exaggerates the melodramatic qualities of the film, while the voguish lettering sought to align *Solaris* with the fashion for the genre of science fiction films in the wake of Stanley Kubrick's *2001: A Space Odyssey* of 1968. Tarkovsky's adaptation of Stanisław Lem's story was a very different kind of philosophical reflection on the Space Age from the poster used to promote it: the planet that gives its name to the film is a mirror of the desires and dreams of the minds of those who encounter it. The Cosmos, in Tarkovsky's vision, remains a metaphysical environment, despite the high-tech achievements of the Space Race.

Overleaf:
Yuri Tsarev, *Solaris*,
poster promoting
the production.
USSR, 1972.
Private Collection

Direccion: Andréi TARKOVSKI

ACTUAN:
NATALIA BONDARCHUK
DONATAS BANIONIS
NIKOLAI GRINKO
YURI YARVET **CAMARA: VADIM YUSOV**
VLADISLAV DVORZHETSKY
ANATOLI SOLONITSIN

SOLARIS

SOVEXPORTFILM

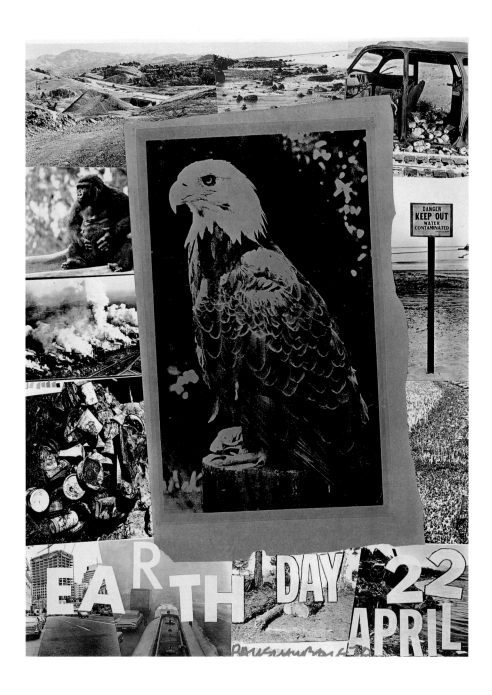

EARTH DAY

Environmental activism gathered pace in the 1960s, becoming a potent political force throughout the world, but perhaps most strongly in the USA. As numerous commentators pointed out, the desecration of the planet was closely connected to the relentless pursuit of economic growth. The 'American way of life', that is, urbanized and motorized high-consumption society, which had been heavily promoted around the world during the first Cold War decade as the counterpart of freedom, was indicted for its effects on the natural landscape at home and abroad. By the end of the 1960s environmentalism had become a mass movement. Its coming out was the celebration of 'Earth Day' for the first time on 22 April 1970 in the form of 'teach-ins' in American colleges and universities, carnivalesque parades and public art projects. Initiated by an American senator, Gaylord Nelson, it attracted the support of Hollywood as well as prominent artists. Robert Rauschenberg set the symbol of America, the Bald Eagle, against images of man's despoliation of the environment as his contribution to the first Earth Day.

Robert Rauschenberg, *Earth Day*, environmental poster issued by the American Environment Foundation. USA, 1970. V&A: E.3035–1991

Richard Buckminster Fuller,
Save Our Planet. USA, 1971.
V&A: E.137–1972

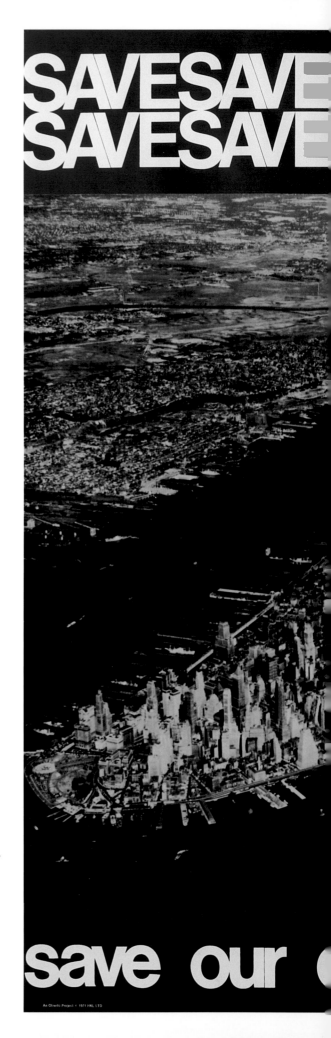

SAVE OUR PLANET

In the early 1960s the American architect and visionary Richard Buckminster Fuller proposed changing the skyline of New York by installing a geodesic dome over Manhattan. One mile high at its centre, this hemisphere was to be three times taller than the Empire State Building. Fuller's logic was environmental. The dome, he claimed, would conserve wasted energy spent heating the city in the winter and air conditioning in the summer. The warm air that would gently lift the structure off the ground would also deliver a hospitable habitat and a new sensibility. Life inside would be a happy arcadia of outdoor restaurants and street art. It was to be a high-tech antidote to the volatile, polluted atmosphere of the industrialized city.

Ten years later Fuller's remarkable image was conscripted to provide a powerful symbol of the dark future facing the planet in the event of nuclear war or rampant industrialization. The poster was published by Olivetti, the Italian corporation, in a series of images by artists reflecting on the state of the planet.

In an age of environmental disasters, mankind would need shelters, the most spectacular of which would be Fuller's 'Dome over Manhattan'. The escalation of the war in Vietnam and the growing recognition of the environmental damage done to the planet had turned Fuller's vision of 1963 from a promise of utopia to a threat of distopia.

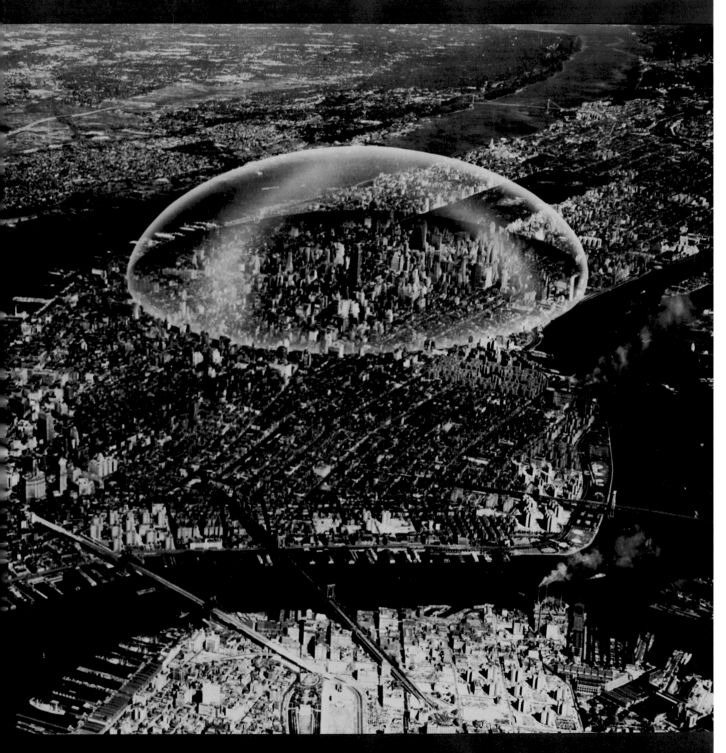

ties

MEXICO 1968

This image was originally produced as a linocut in 1954 by the artist Adolfo Mexiac (a member of the Taller de Gráfica Popular, a left-wing printmaking workshop formed in the late 1930s). The image acquired new significance in the 1960s when student protests in Mexico gathered pace. The ruling regime was viewed as stagnant and self-serving, whilst the majority of the population lived in poverty. Mexican radicals regarded the impending Olympics in the summer of 1968 as a circus designed to distract the country from its social crisis, a view captured in the slogan 'We Don't Want Olympic Games, We Want Revolution!' Protests climaxed tragically in the Tlatelolco massacre in Mexico City, in which the security forces killed hundreds of students ten days before the opening day of the Olympics. The violence prompted Mexiac to reproduce his image as a lithograph with the official Olympic logo, which he gave to students to support their protests.

Facing page:
Adolfo Mexiac,
*Mexico 1968 —
Libertad de expression.*
Mexico, 1968.
V&A: E.1517–2004

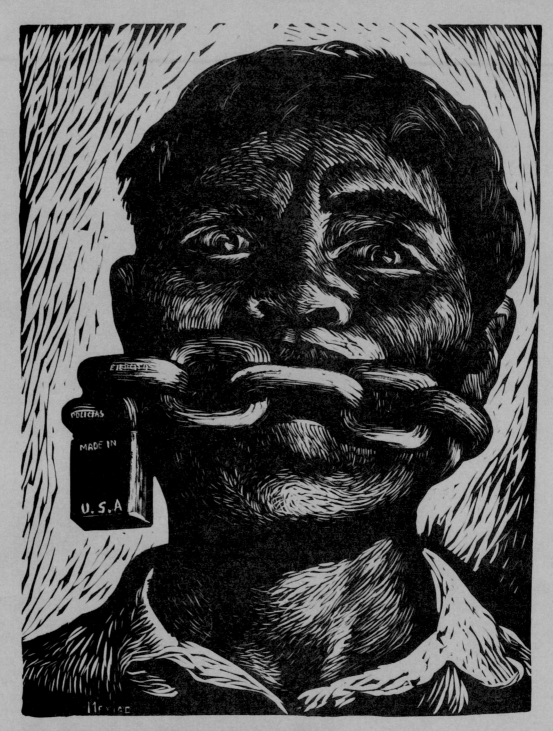

LIBERTAD
DE EXPRESION

US HANDS OFF CHILE

In the early 1970s many on the Left around the world were critical of US foreign policy in Latin America. Chile proved to be a rallying call when President Salvador Allende's Popular Unity government was deposed in a *coup d'état* in 1973. The US Government became concerned about the warm relations between Santiago and Moscow after Allende had taken power in 1970. Washington was anxious to stem what it viewed as the spread of communism in the region, as well as to reverse the nationalization of American business interests in the country. In September 1973 the military took over the country, deposing Allende's government. The CIA denied any involvement in the events that led to Allende's death and the imposition of a dictatorship under General Pinochet. Nevertheless, many commentators around the world viewed the USA as complicit in the coup.

Exiles from Pinochet's regime protested against the suppression of democracy in Chile. Campaigning groups were established throughout Europe and North America. This poster produced by the Chile Solidarity Committee in New York one year after the coup, indebted to the bold colours and free drawing style of the Cuban poster, exploits the conventional symbolism of clenched fist and red stars characteristic of much pro-Allende propaganda.

Unknown designer,
US Hands Off Chile
El Pueblo Vencerá,
issued by the Chile
Solidarity Committee,
New York. USA, 1974.
V&A: E.330–2004

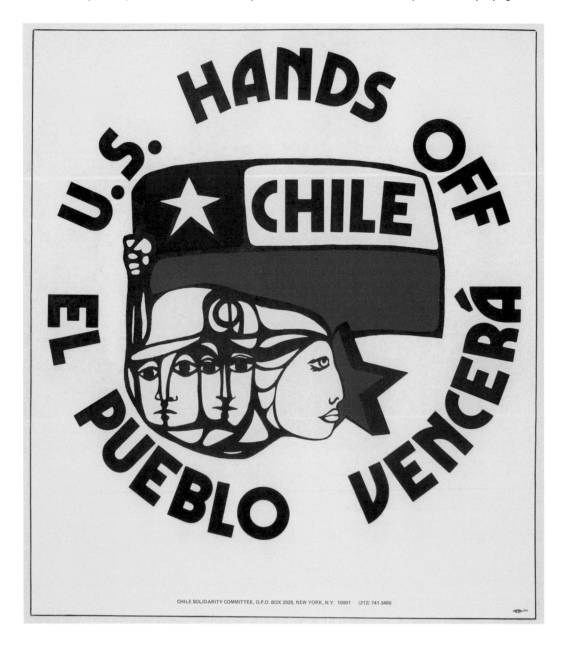

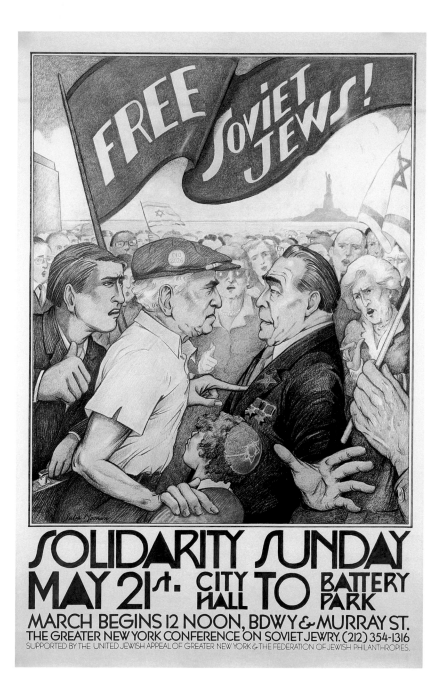

Norman Julia, *Free Soviet Jews!*, poster issued by the Greater New York Conference on Soviet Jewry. USA, late 1970s. Private Collection

FREE SOVIET JEWS

Life became increasingly difficult for many Jews living in the Soviet Union in the 1970s. The daily privations suffered by all citizens were amplified by increasing official criticism of the policies of Israel, a form of camouflage for anti-Semitism. After the Arab–Israeli War of 1967, increasing numbers of Soviet Jews applied to leave the country for Israel, where they were guaranteed refuge.

The Soviet authorities were highly obstructive, eventually imposing a considerable tax for exit visas.

The cause of Soviet Jewry became a Cold War theme when protest groups in the West attacked Kremlin policy as a symptom of Soviet repression. Norman Julia's poster produced by the Greater New York Conference on Soviet Jewry makes the most direct attack on the Soviet leadership by depicting a crowd challenging the figure of the Soviet head of state, Leonid Brezhnev. The background contains two symbols of human rights, the *Statue of Liberty* and the headquarters of the United Nations, which had published the Universal Declaration of Human Rights in 1948 (a statement that the Soviet Union had refused to endorse).

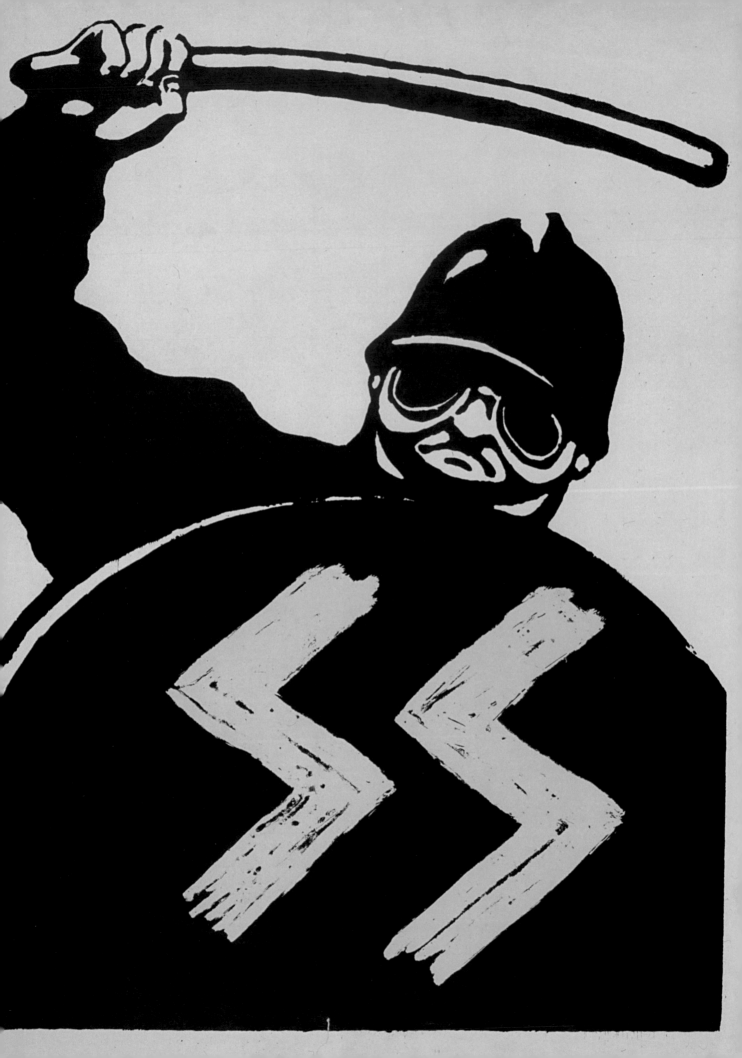

2

THE STREET-FIGHTING YEARS

The idea of revolution had high currency around the world in the 1960s. The conviction that society could be dramatically reorganized at a stroke by an act of revolution motivated a new generation of activists. From the perspective of radicals in the West, frustrated with the conservatism and consumerism of the social systems in which they lived, China, Cuba and countries in the developing world seemed to set the pace, providing numerous and, to many, attractive images of revolution. Ernesto 'Che' Guevara was the pin-up of the age. Drawn to the charismatic veteran of the Cuban Revolution after a meeting in 1960, Jean-Paul Sartre described him 'as the most complete man of his generation. He lived his words, spoke his own actions, and his story and that of the world ran parallel'.[8] This was more than simply a eulogy. For 'café intellectuals' like Sartre, Che represented an ideal: a man, trained as a doctor, who was prepared to take up arms to change the world for the benefit of all.

Mao's China also provided radicals in the West with images of a society throwing off the shackles of tradition. In 1966 the most populous nation on earth was convulsed into violent revolution by the Chairman's declaration of the Great Proletarian Cultural Revolution. The Soviet path — which China had been following since 1949 — had led to bureaucracy, famine and economic crisis. Mao's answer to his own mismanagement was to declare revolution. A revolutionary force, the Red Guards, was unleashed on society to destroy any vestiges of older ways of thinking or being. The reality of the Cultural Revolution was appalling violence and chaos. In towns and cities throughout the country, libraries and Buddhist temples were destroyed; officials were dragged before enormous crowds to be mocked and beaten; and different factions engaged in pitched battles. In this living nightmare, the streets became a frenzied battleground without clearly defined fronts. Moreover, buildings, squares and even

Facing page:
Atelier Populaire, *SS*.
France, 1968.
V&A: E.225–1985

pavements were dressed with enormous calligraphic posters — known as *dazibao* — that declared the aims of the Cultural Revolution and denounced its opponents.

In the iconoclastic political atmosphere of the 1960s, many radicals were highly critical of the USA and the USSR. The superpowers were accused of exercising a destructive influence on the rest of the world and of betraying their own origins in revolutions motivated by high ideals. This point was made graphically by the Polish artist Roman Cieślewicz, who was living in Paris. In 1967 he depicted the two superpowers as mirror images of each other in a cover design for the Paris-based left-wing art magazine *Opus International*. Che Guevara, as a minister in the Cuban government, made a similar point in a speech in Algiers in 1965, when he accused the Soviet Union and its allies in the Eastern Bloc of 'tacit complicity with the exploiting countries of the West'.[9]

In the late 1960s revolutionary images were adopted in the modish fringes of consumer culture. In 'Street Fighting Man', Mick Jagger of the Rolling Stones, for instance, sang about the excitement of witnessing demonstrations around the world from the perspective of 'sleepy London town'. Writing in 1967, Raoul Vaneigem dubbed the popularity of such images of

revolution 'radical chic'.[10] In fact, the French poster studio established to serve the student protests in Paris in 1968 published a clear embargo on the commodification of its products:

> The posters produced by the Atelier Populaire are weapons in the service of the struggle and are an inseparable part of it. Their rightful place is in the centres of conflict, that is to say, in the streets and on the walls of the factories. To use them for decorative purposes, to display them in bourgeois places of culture or to consider them as objects of aesthetic interest is to impair both their function and their effect. This is why the Atelier Populaire has always refused to put them on sale.[11]

Such embargos had relatively little effect. As the American writer Susan Sontag noted in her discussion of the vogue for Cuban posters in the West, consumption in capitalist societies is based on appropriation: 'counter-revolutionary societies … [have] a flair for ripping any object out of context and turning it into an object of consumption'.[12]

Cuban posters of the mid-1960s drew warm praise around the world for their vivid fields of colour and uninhibited designs. They were produced in straitened circumstances: paper supplies were limited and early posters were usually screen-printed by hand (rather than lithographically printed as was the convention in Europe and North America). The diversity of styles, it seems, was a living proof of Fidel Castro's contract of 1961 to withdraw from questions of artistic form, in exchange for Party control of content. Although Sontag argued that undisciplined aesthetics lacked the discipline to be truly revolutionary, she did see the contours of freedom in their hedonism. Perhaps alluding to the Soviet Union, she wrote these words in 1970:

> These posters give evidence of a revolutionary society that is not repressive and philistine … a culture which is alive, international in orientation and relatively free of the kind of bureaucratic interference that has blighted the arts in practically every other country where a communist revolution has come to power.[13]

Like many sympathetic observers of Castro's revolution, Sontag hoped to find in Cuba what had been lost in the bureaucracy, gulags and blinkered industrialization associated with the Soviet experience — the possibility of a genuinely radical culture.

Roman Cieślewicz, *Supermen*, a poster published by Georges Fall. Paris, 1968. National Museum, Poznań

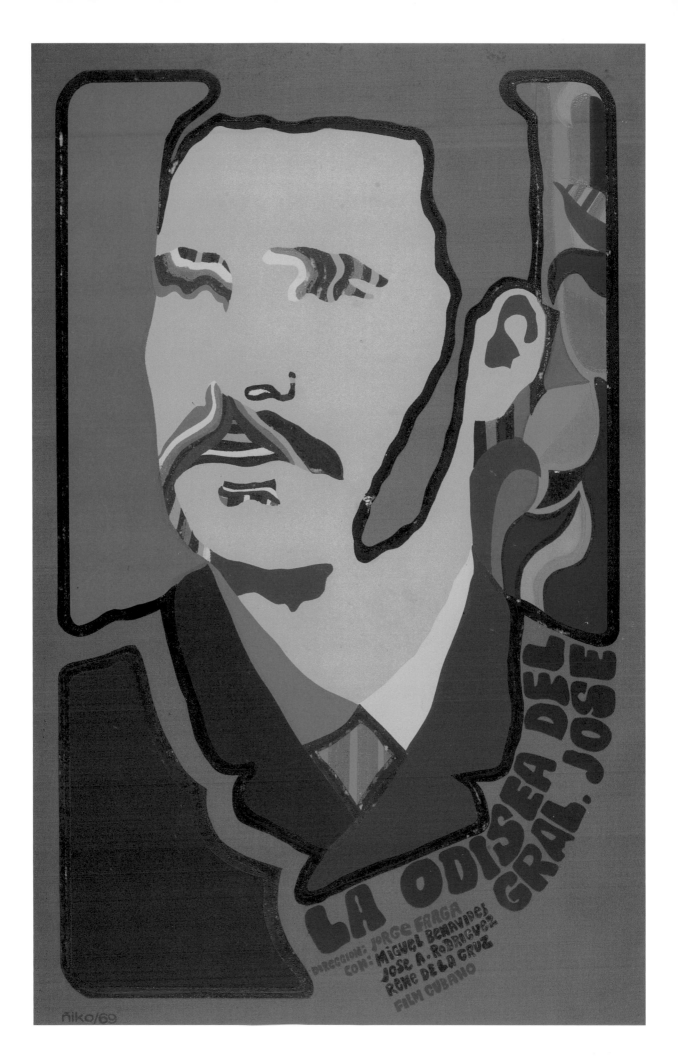

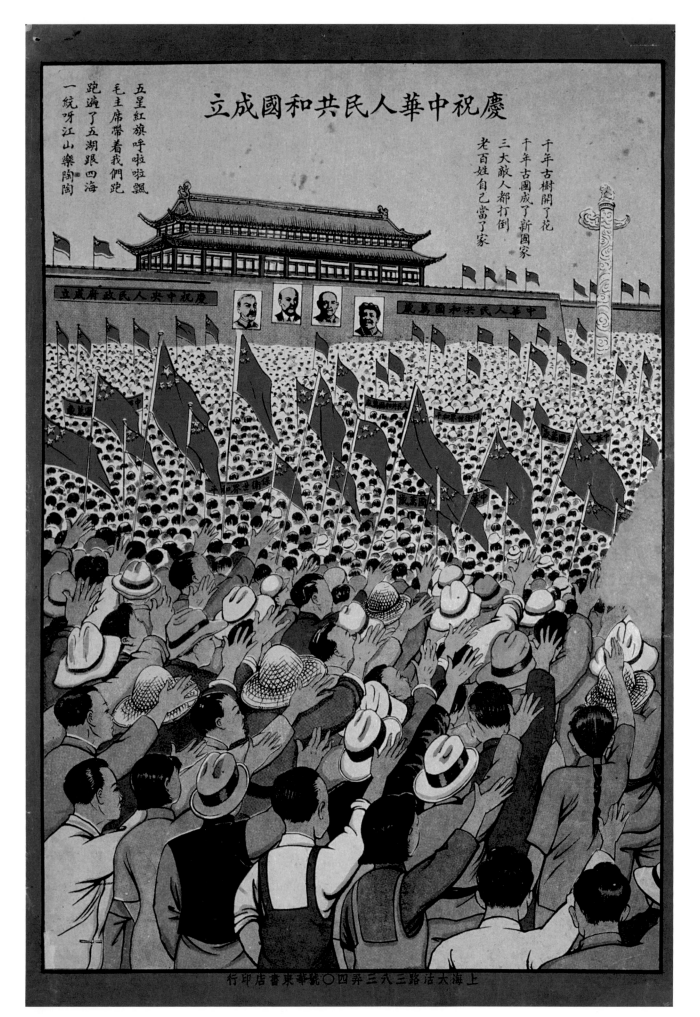

MAO IN TIANANMEN

This small poster celebrates the founding of the People's Republic of China, which Mao Zedong declared at the Rostrum gate in Tiananmen Square in Beijing in October 1949. The thronging crowd hails poster portraits of communist leaders in the square. The portraits appear to represent Stalin, Lenin, Lin Biao (the Chinese soldier and statesman who, as commander of the First Red Army Corps, played a major role in the Communist victory against the Guomindang in 1949) and Mao. Over time, Mao's neighbours disappeared and his portrait was replaced by a massive oil painting of the leader in his trademark grey suit. In this way, Mao was made into the deity of a monotheistic religion, Chinese communism.

Facing page:
Unknown designer,
Tiananmen Square.
China, 1950.
V&A: FE.20–1994

Facing page:
Unknown designer,
*Down with US
Imperialism, Down with
Soviet Revisionism*,
poster produced during
the Cultural Revolution.
China, 1967.
Private Collection

DOWN WITH US IMPERIALISM, DOWN WITH SOVIET REVISIONISM

Mao Zedong built an effective personality cult in China, which still protects his reputation today, long after his death in 1976. During the Cultural Revolution, the poster was used to turn the Chairman of the Communist Party of China into the only stable point in a society in revolutionary chaos. Mao had in fact spoken out against the blind adoration of revolutionary leaders during the 1950s, but the Red Guards who convulsed China into crisis treated his *Quotations from Chairman Mao* (better known as the 'Little Red Book', first published in May 1964) as a bible and his image as a sacred icon. Regional Party leaders were toppled, accused of creating rival cults or of emulating Mao's style of dress or manner. In this poster published in 1967, Mao's portrait occupies the place of the sun, radiating not light but revolutionary energy, which is absorbed by the international band of freedom fighters below.

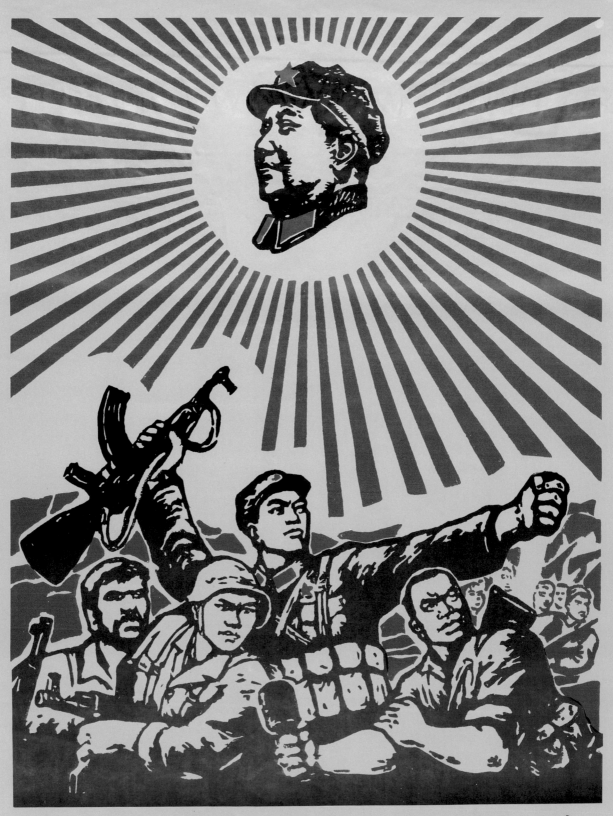

打倒美帝打倒苏修

1967 年西安交通大学反到底兵团三二四纵队

LA CHINOISE

Maoism attracted its acolytes in the West, with the image of the Chairman being paraded in the student demonstrations of the 1960s. Perhaps the most famous of the Western Maoists was the French film director Jean-Luc Godard, whose prescient film *La Chinoise* (1967) anticipated the revolutionary manoeuvres in the French capital in 1968 and commented on the growing antipathy to both American and Soviet power.

The climax of Godard's film is an attempt to assassinate the Soviet Minister of Culture when he makes an official visit to France (an event represented by a brief cut to a comic-book image of violence). Hans Hillman's poster — promoting the film in West Germany — uses the star motif that is a historic symbol of revolutionary communism to obscure the face of the central character, who is barricaded with a gun behind a wall made from Mao's 'Little Red Book': her identity is lost when she gives herself over to revolutionary violence.

Hans Hillman, poster promoting Jean-Luc Godard's film *La Chinoise*. West Germany, 1967. Private Collection

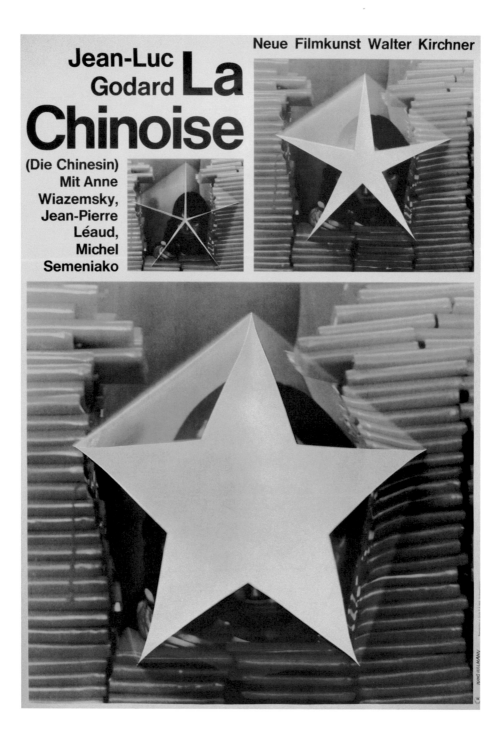

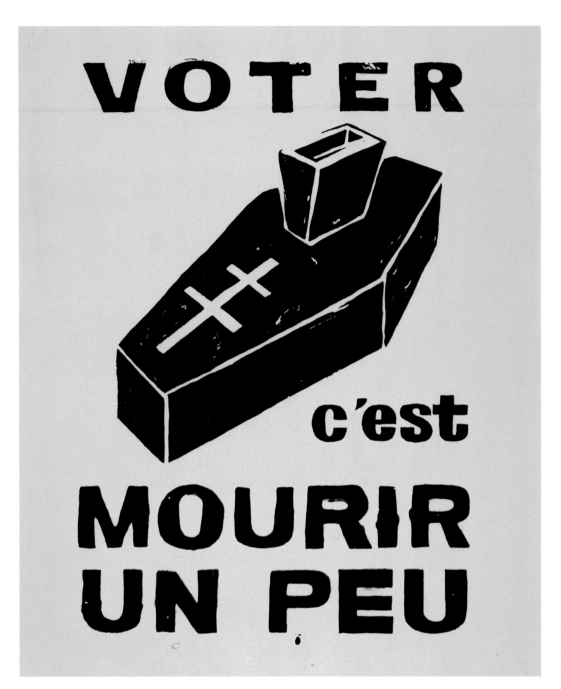

Atelier Populaire,
Voter c'est mourir un peu
('To Vote Is To Die a
Little'). France, 1968.
V&A: E.668.2004

TO VOTE IS TO DIE A LITTLE

In the spring of 1968 French students and workers tested the conservative government of Charles de Gaulle with a series of strikes, demonstrations and street unrest. On 18 May some 10 million workers went on strike and many factories and universities were occupied. Some of De Gaulle's opponents were protesting against unemployment and poor working conditions; others had greater ambitions and were seeking to overturn parliamentary democracy in favour of workers' councils and libertarian communism. Protests in Paris were supported by the Atelier Populaire, the poster-producing studio in the Ecole des Beaux-Arts. When the college went on strike, a number of students met spontaneously in the printmaking department. Unsigned — the collective output of anonymous designers and printers — the posters had a direct and immediate appearance: they were screen-printed in a single colour and combined powerful graphic motifs and slogans.

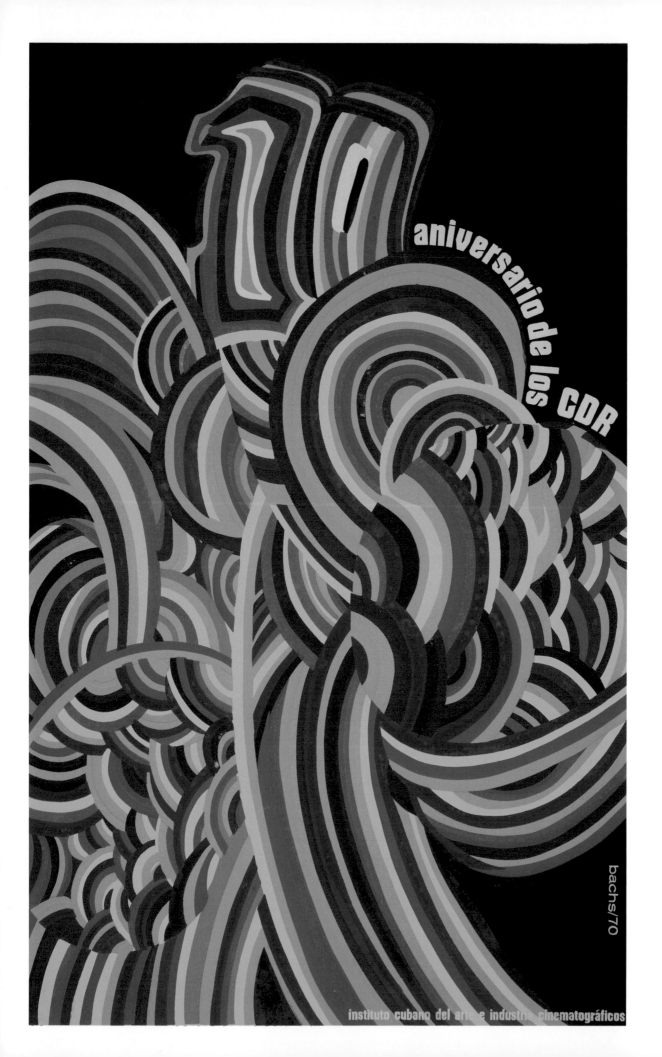

10 aniversario de los CDR

bachs/70

instituto cubano del arte e industria cinematográficos

Facing page:
Eduardo Bachs, *10 aniversario de los CDR* ('10th Anniversary of the CDR'), poster issued by the Instituto Cubano del Arte e Industrias Cinematográficos (ICAIC). Cuba, 1970.
V&A: E.770–2003

DEFENDING THE REVOLUTION

Some of the most strikingly lyrical and abstract Cuban posters signified the complete loyalty to the revolution that Fidel Castro demanded of all Cubans. Eduardo Bachs's poster commemorating the ten-year anniversary of the establishment of the network of Committees for the Defense of the Revolution (Comités de Defensa de la Revolución / CDR), for instance, is a rippling rainbow of pulsing lines. As vibrant as any psychedelic poster produced in North America or Europe in the period, Bachs's design suggested the interconnectedness of the CDR and the living energy of Castro's revolution.

The CDR ran a network of informants and Party workers that operated at the ground level of Cuban society. This network worked in close collaboration with the Ministry of the Interior to repress opposition on the island, as well as managing benign matters such as vaccination campaigns.

THE BAY OF PIGS

In 1961 the Kennedy administration sanctioned an invasion of Cuba by anti-communist exiles to trigger what the CIA hoped would become an uprising on the island. The event was a debacle, partly because of Kennedy's desire to make it look as if it had been conducted by Cuban exiles alone, and the counter-revolutionaries were repulsed at considerable cost to life. This event — known as the Victory at the Bay of Pigs — was written into Cuban history by Castro's regime to lend weight to its claims for the inevitable success of the Cuban Revolution. Niko's poster of 1971 — produced on the tenth anniversary of the failed invasion — is an elegant and efficient design capturing the sinking of an American vessel in a few simple bands of colour (though no such event occurred). The dishevelled Stars and Stripes ingeniously capture the disorder felt in Washington by the turn of events.

Overleaf:
Niko, *X anniversario de la victoria de playa girón* ('The Tenth Anniversary of the Victory at the Bay of Pigs'), poster commissioned by the Instituto Cubano del Arte e Industrias Cinematográficos (ICAIC). Cuba, 1971.
V&A: E.760.2003

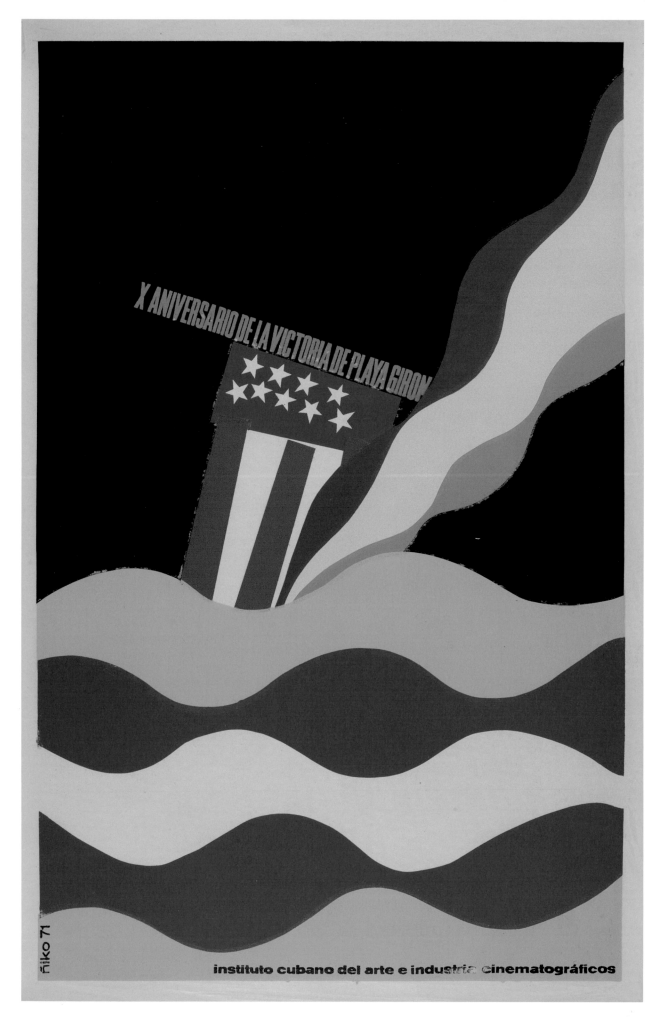

THE SUPPRESSION OF THE PRAGUE SPRING

This poster was produced by Václav Ševčik to protest against the invasion of Czechoslovakia in August 1968 by Warsaw Pact forces led by the Soviet Union. The reform movement — which had been growing in the country during 1967 and 1968 — had been stimulated by hope in the possibility of a fundamental change in communist rule. Reformist leaders within the Party had declared the necessity of 'socialism with a human face' based on freedom of speech, the end of censorship and the extension of democratic rights. In the fast turn of events, the unstable line between state and opposition became unclear: in March 1968, for instance, the censorship board, a committee stacked with communists, called for its own dissolution. Alarmed by this unpredictable situation, Moscow put an end to the Prague Spring by sending in tanks in the summer of 1968.

When, twenty years later, Czechoslovakia threw off communist rule during the Velvet Revolution, Ševčik dusted down a number of his 1968 posters and wrote the date — 17 November 1989 — in pen below the printed date and pasted them up in Prague theatres and universities. The two dates bracketed a period of mourning for the loss of Czechoslovak freedom.

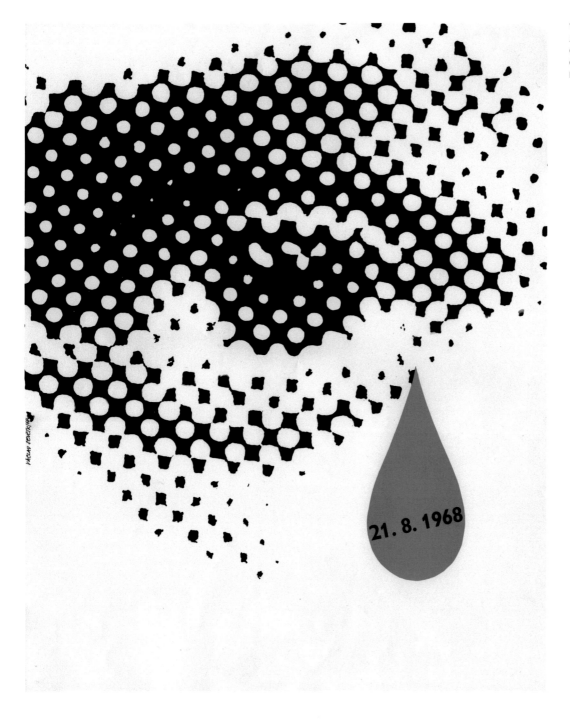

Václav Ševčik,
21 August 1968.
**Czechoslovakia, 1968.
Collection of the
National Gallery, Brno**

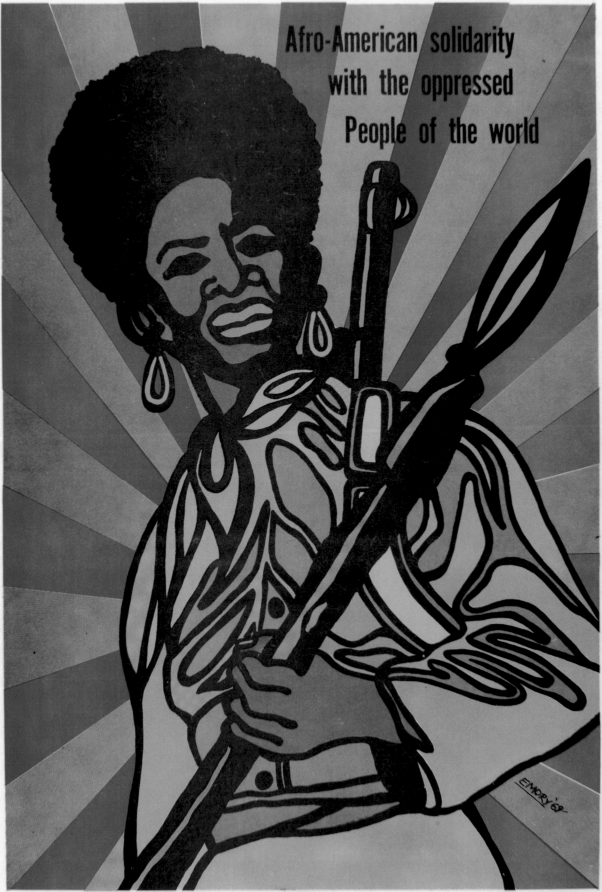

Afro-American solidarity
with the oppressed
People of the world

Revolutionary art by
Minister of Culture
EMORY

EMORY '68

Ministry of Information
Box 2967, Custom House
San Francisco, CA 94126

SOLIDARITY WITH THE OPPRESSED PEOPLE OF THE WORLD

In this poster produced at the height of the revolutionary fervour of the 1960s, the designer, Emory Douglas, made a clear connection between the interests of African-American people and those living in the developing world. His revolutionary — displaying her black pride in her Afro hair and militant posture — carries both a rifle and a spear. Like the image of Mao on page 55, she seems to take on a consecrated form by the golden lines that radiate from her body.

This poster was issued by the Black Panthers, a militant group formed in 1966 that eschewed the pacificism of earlier civil rights activists in the USA in favour of what it called 'self-defence'. The socialist group also engaged in peaceful activities, such as the feeding of poor children in San Francisco. The poster strikes a provocatively Soviet note in identifying Douglas as the Minister of Culture and the publisher as the Black Panthers' Ministry of Information.

Facing page:
Emory Douglas,
Afro-American Solidarity with the Oppressed People of the World,
poster issued by the Black Panthers.
USA, 1969.
V&A: E.756–2004

VENCEREMOS

Even before his death in Bolivia in 1967, Che Guevara was an icon. He recognized the powerful effects of his image. When he spoke at the United Nations before the world's cameras in 1964, he dressed in uniform as if ready for combat. In 1965 he left Cuba to promote the cause of world revolution, first fighting in the Congo and then in 1967 in Bolivia, where he was eventually captured and executed. When Castro announced Che's death a few days later in Havana, the now famous iconic image of Che, taken by Alberto Korda, was blown up and draped over the square where the speech was made. Like the photograph — which now adorns countless t-shirts and postcards — this poster, produced in Mexico in the early 1970s, represents Che as a visionary, his eyes focused on the symbolic horizon of revolution. Captioned with the ringing slogan 'We Will Win', the poster was probably produced in the aftermath of the violent repression of student protest in the country in 1968.

Overleaf:
Unknown designer,
Venceremos ('We Will Win'), student poster.
Mexico, c.1970.
V&A: E.685.2004

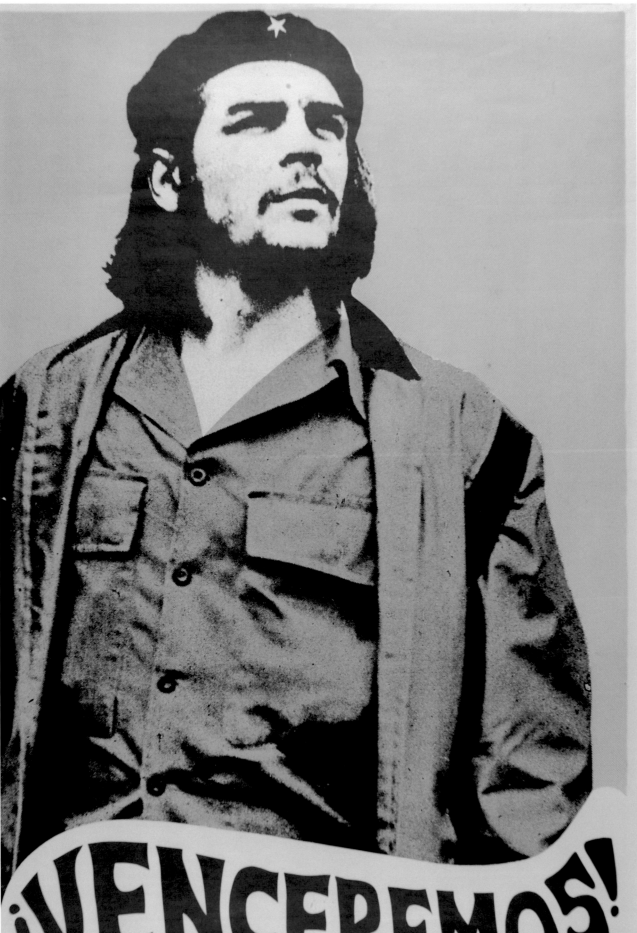

SOLIDARITY WITH THE AFRICAN AMERICAN PEOPLE

This poster — issued by OSPAAAL (Organization of Solidarity of the People of Asia, Africa and Latin America) — emphasizes Cuban solidarity with African-Americans fighting for their rights in the USA. Fidel Castro presented the Caribbean island as the friend of small nations living in the shadow of aggressive neighbours and a sanctuary for revolutionaries around the world. Black leaders in the United States were drawn, with Havana's encouragement, to Cuba, particularly after the explosive Watts Riots in Los Angeles in August 1965. Robert Williams, the radical Marxist leader of the Black Liberation Front, lived in Havana between 1961 and 1966 before leaving for Mao's China. Black Power activists, including Stokely Carmichael and Eldridge Cleaver, followed in his footsteps in 1967 and 1968, before leaving for Africa to agitate for their visions of pan-Africanism there.

Lazaro Abreu, with an illustration by Emory Douglas, *Solidarity with the African American People*, published by OSPAAAL (Organization of Solidarity of the People of Asia, Africa and Latin America). Cuba, 1968. V&A: E.798.2004

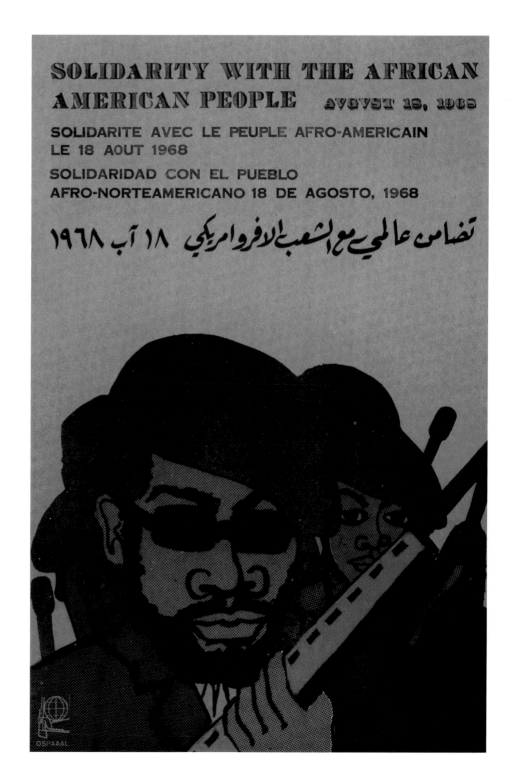

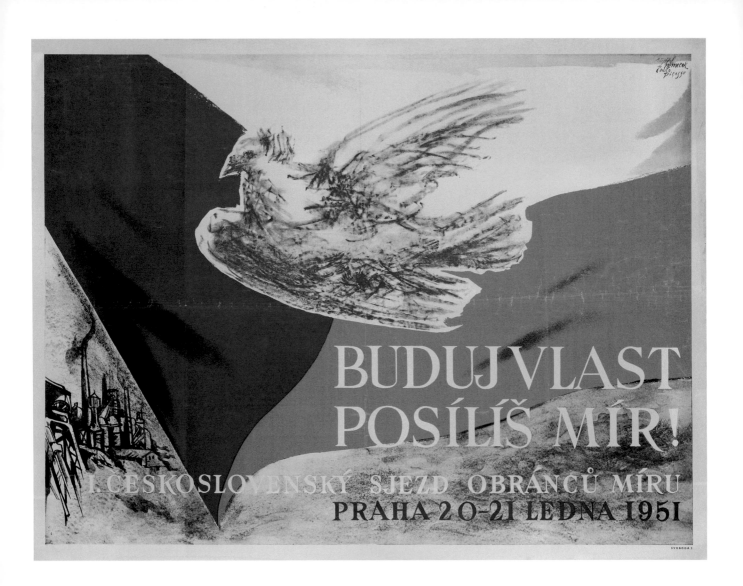

3
FIGHTING FOR PEACE

'Peace' was one of the most used and most abused words of the Cold War years. The combination of massive armouries of nuclear weapons and sharp ideological divisions presented mankind with the most terrifying vision of the future, one of nuclear apocalypse. From the late 1940s until the end of the 1980s East–West relations went through cycles of high tension and relative calm. These moments were measured from 1947, when the Board of Directors of the *Bulletin of the Atomic Scientists* established the Doomsday Clock at the University of Chicago. A symbolic gauge that measured man's advance towards the hour of nuclear war, the time was set at two minutes to midnight in 1953 — its closest approach to Doomsday — when the two superpowers tested thermonuclear devices within a few months of each other. By contrast, the clock was reset to the relative calm of 11:43 in 1991 at the end of the Cold War, when the Strategic Arms Reduction Treaty was signed by the USA and the USSR.

Most historians (if not the Chicago scientists) agree that the world drew closer to a third world war in the early 1960s, in a series of events that included the shooting down of an American U2 high-altitude reconnaissance plane over Sverdlovsk in the USSR in 1960; the crisis that saw the erection of the Berlin Wall in 1961; and, most dramatically, the Cuban Missile Crisis in the autumn of 1962, when US spotter planes identified Soviet missile bases being built on the Caribbean island. President Kennedy went on American television to announce that it was the 'policy of this nation to regard any nuclear missile launched from Cuba against any nation in the Western Hemisphere as an attack on the United States, requiring a full retaliatory response upon the Soviet Union'.[14] Tensions abated only when the Soviet premier Khrushchev announced on Radio Moscow his intention to pull the Soviet arms back.

Peace activists in the West invested considerable effort into campaigns to compel the superpowers to dismantle the rapidly growing numbers of nuclear weapons in the world. In the UK the Campaign for Nuclear Disarmament (CND, founded 1958) was an effective campaigning body, reminding the public of the threat that Cold War enmities constituted to their lives. It used public marches (most famously to the Atomic Weapons Establishment near Aldermaston) and poster art to great effect.

Facing page:
Vojtek Němeček (with drawing by Pablo Picasso), *Buduj vlast posilis mir!* ('Build a Lasting Peace for the Homeland!'), a poster announcing the Czechoslovak Rally of Peace Fighters, Prague. Czechoslovakia, 1951. Private Collection

CND provided the world with a new logo for peace activism, a circular motif bisected by flaring lines. Designed in 1958 by Gerald Holtom, a graduate of the Royal College of Art, it was first employed on 'lollipop' signs carried by CND members on their Aldermaston march of Easter 1958. The symbol was then remade as button badges in white clay and distributed with a poignant note explaining that, in the event of a nuclear war, these fired ceramic badges would be among the few human artefacts to survive. Curiously, very few anti-nuclear posters in the West represented the scenes of devastation resulting from the detonation of the bomb: the strangely enigmatic symbol of the mushroom cloud ballooning up into the sky was sufficiently understood to deliver its message. Peter B. Hales has called the powerful effect of this much-reproduced image the 'atomic sublime', an aesthetic that generates both horror and fascination.[15]

In the paranoid minds of hawks on the American Right, the peace movement in the West was a front for Soviet foreign policy. This was an easy and largely unfounded smear. Nevertheless, peace was given a central place in Soviet rhetoric. The word operated like a brand in the Eastern Bloc, being fixed on what seemed to be every event and inscribed across numerous buildings and products. Schools and factories were compelled to form 'peace committees'; sportsmen and women would compete in peace races; and activists would be awarded peace-fund medals. Like a logo, the biblical symbol of the white dove decorated every tribune and parade, sometimes in the beautifully calligraphic form created by Picasso, perhaps the best-known communist in the West in the post-war years. Anti-Soviet campaigning groups invested great energy in exposing the hollow heart at the centre of Soviet peace rhetoric. After all, Warsaw Pact troops under Soviet command invaded Hungary in October 1956 and Prague in 1968, in direct violation of the Warsaw Pact agreement not to interfere in the internal affairs of member states. In a series of posters produced in the early 1950s, Paix et Liberté, for instance, represented the peace dove as Stalin's chained pet and as a tank ('The Dove That Goes Boom').

East–West tensions never spilled into violent conflict in the primary Cold War battleground of Europe, but they led to considerable violence elsewhere in the world. Moscow and Washington fought each other through proxy states. The Korean War (1950–53) and the Vietnam War

(a simmering conflict that ignited in 1965) were escalated by American intervention in order to stop the spread of communist influence in the world. The Vietnam War in particular became a crucial cause for peace activists throughout the globe. Some of the most sardonic images of the twentieth century were produced in response to American actions in Indochina. When commissioned by a New York anti-war group in 1969 to design a poster, the graphic designer Robert Brownjohn simply wrote 'pe' and a question mark in loose hand lettering on either side of a playing card, the ace of spades. 'Peace' became a word of warning. At the height of the conflict in Vietnam, his use of this traditional symbol of death and a term of racial abuse ('spade') made the poster both a powerful indictment of America's foreign policy and of the fact that proportionately more black Americans than whites were conscripted to take up arms.

After a period of détente in the 1970s, Cold War fears rose again in the 1980s when President Reagan in the USA restarted the arms race, announcing the Strategic Defense Initiative (dubbed the 'star wars' programme), a space-based weapons system. Speaking in the British parliament, he called the Soviet Union an 'Evil Empire' and predicted that it would be consigned to the 'ash heap of history' for its abuses of human rights and for the invasion of Afghanistan. This was a description that sounded much like a threat. The Doomsday Clock was reset again, this time alarmingly close to the midnight hour. The new warmongering rhetoric was, however, matched by a tremendous wave of peace activism. CND in Britain enjoyed a rapid renewal of membership and a new generation of artists lent their services to the cause of peace. Events in Moscow were to play their part too. Under President Gorbachev, who took power in 1985, the Soviet Union began making good on its promises on peace, and the Directors of the *Bulletin of the Atomic Scientists* were able to set the hands of the Doomsday Clock back.

PE ?

Love -Bj.

l'atome au service de la paix

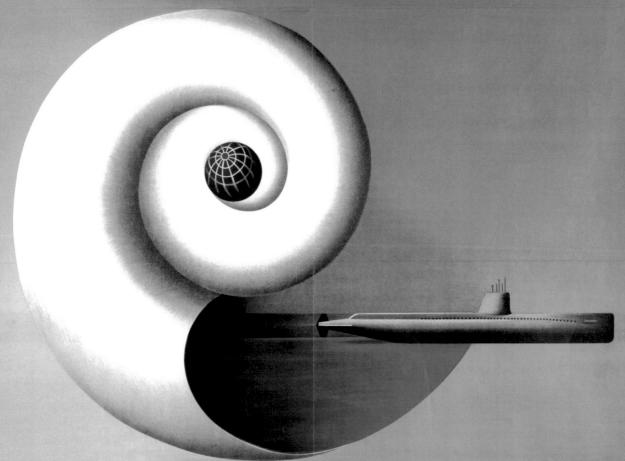

hydrodynamics

PRINTED IN SWITZERLAND

GENERAL DYNAMICS

Geneva. August 8-20

LITHOS R. MARSENS, LAUSANNE

ATOMS FOR PEACE

The phrase 'Atoms for Peace' was set into the heart of Cold War discourse by the US President, Dwight D. Eisenhower, in a speech at the United Nations in 1953. After the considerable anxiety released by the arms race, this speech represented a powerful statement of faith in man's ability to employ atomic weapons for good. Scientific research, Eisenhower and others argued, could provide cheap and clean energy, as well as stimulate considerable advances in medicine and even train the capacities of nuclear explosions to reshape the landscape. General Dynamics, a corporation with deep roots in weapons research, seized the term in order to promote its products, which included the first atomic-powered submarine, the USS *Nautilus*. The graphic designer Erik Nitsche — employed by the company from 1955 to manage its public image — produced this picture, one of six multilingual posters designed to appeal to a European audience at a gathering of scientists in Switzerland. Representing 'hydro-dynamics', the design featured the submarine bursting out of the hollow chamber of a nautilus shell against a gradated grey background. Making no reference to its destructive capacities, the submarine was seen, in Steven Heller's words, as the 'offspring of progress poised to help the world'.[16]

Facing page:
Erik Nitsche, *L'Atom au service de la paix* ('The Atom in the Service of Peace'), a poster issued by General Dynamics. USA, 1955.
V&A: E.1310–2004

PEACE IN STOCKHOLM

Picasso's characteristically expressive sketch of two hands grasping a colourful bouquet of flowers was used to promote the Congress for Disarmament and International Cooperation held in Stockholm in 1958. This gathering of peace activists from around the world included delegates from both sides of the Bloc. They focused their attentions on the spread of nuclear weapons, placing particular emphasis on American development of the technology of annihilation. Picasso's design — representing the shared grip of two hands, or perhaps the passing of the bouquet from one hand to another — captured the meeting of East and West that the organizers of the Congress hoped to achieve in the Swedish capital. In the end, however, the event was disrupted by a young American protester, who seized the stage in order to denounce the Soviet role in the arms race.

Overleaf:
Pablo Picasso, *Paix. Stockholm*, 16–22 July 1958. Published in France, 1958.
V&A: E.1843–2004

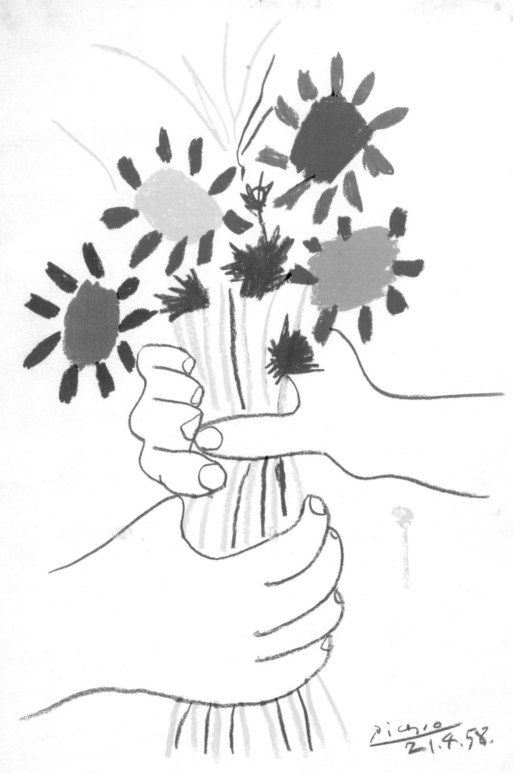

PAIX.STOCKHOLM
16 - 22 JUILLET 1958

STOP NUCLEAR SUICIDE

In the early 1960s the world seemed to be tipping towards a third world war. The capture of an American spy plane in 1960, the building of the Berlin Wall in 1961 and the Cuban Missile Crisis in October 1962 all had the effect of putting America and the Soviet Union on a war footing.

In London, F.H.K. Henrion's poster *Stop Nuclear Suicide*, commissioned by CND, rejected the theory of Mutually Assured Destruction (MAD), the military doctrine that argued that war was inconceivable when both sides

possessed nuclear weapons. Combining a powerful historic symbol of death, the skull, with another modern one, the mushroom cloud released after a nuclear explosion, Henrion's message was devastatingly simple. Despite such powerful propaganda, some were prepared to conceive of life after the apocalypse. Imagining a victorious America after a nuclear confrontation, the US military strategist Herman Kahn wrote: 'it is not true that everyone is killed but that only 50 million are'.[17] The loss of one in three American lives and the human and environmental consequences of nuclear fallout were, according to Kahn, worth considering as the price of victory.

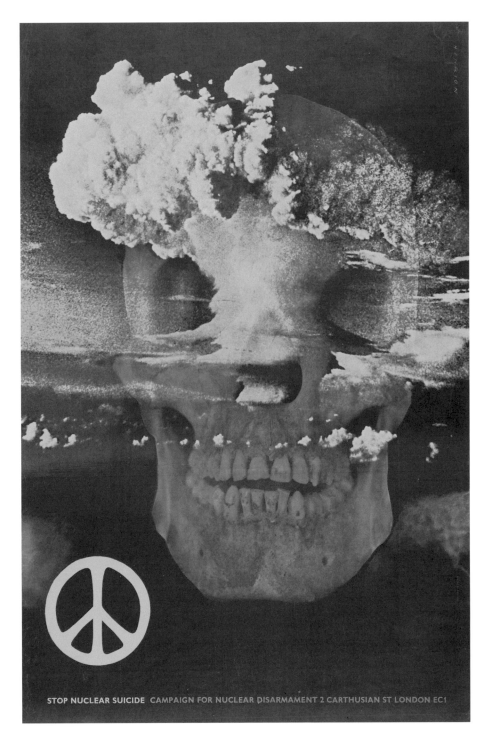

F.H.K. Henrion,
Stop Nuclear Suicide,
poster commissioned
by the Campaign for
Nuclear Disarmament
for London Underground
stations. UK, 1963.
V&A: E.3910–1983

STOP NUCLEAR SUICIDE CAMPAIGN FOR NUCLEAR DISARMAMENT 2 CARTHUSIAN ST LONDON EC1

THE PEACE RACE

Peace was a constant theme of Soviet propaganda during the Cold War, a rhetoric that was belied by the violent suppression of the Hungarian Uprising in 1956 and the repression of the Prague Spring twelve years later. Peace propaganda took various forms, including the famous annual 'Peace Race' (*Friedensfahrt* in German, *Wyścig Pokoju* in Polish and *Závod Míru* in Czech), which was first held between Prague and Warsaw in 1948. Four years later it was extended to include Berlin, a symbolic

gesture to welcome the East German state into the brotherhood of socialist nations. The fact that the competitors were amateurs, competing for national pride, also extended the socialist credentials of this event. The Peace Race of 1956 — promoted by the Czech designer Pánek's dynamic poster — was won for the first time by a team from the Soviet Union known as the *Sbornaja Komanda* ('Select Team'), and marked the beginning of a decade of Soviet dominance of the event, a fact that attracted the scorn of many of the crowds watching the race in the Central European states through which it passed.

Trybuna Ludu - NEUES DEUTSCHLAND RUDÉ PRÁVO

ZÁVOD MÍRU
WARSZAWA · BERLIN · PRAHA
2.-15. KVĚTNA 1956

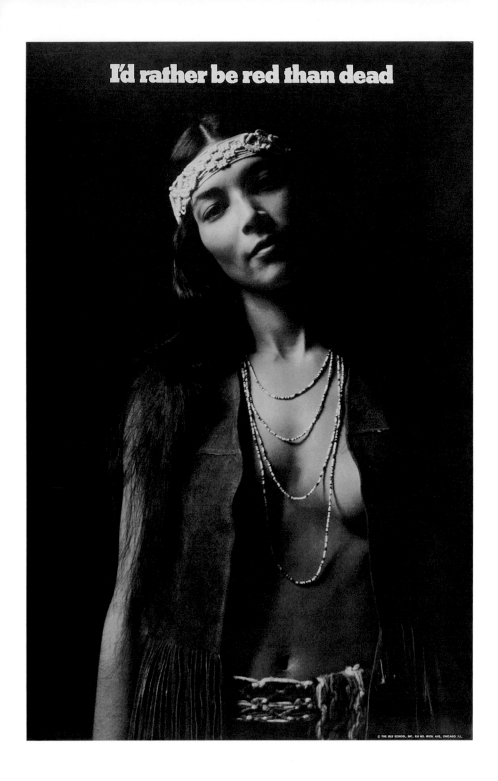

I'd rather be red than dead

RED OR DEAD?

This poster reversed the cliché of patriotic America in the 1960s, 'I'd Rather Be Dead than Red.' The slogan was associated with conservatives such as Young Americans for Freedom, which countered the anti-Vietnam War movement in American universities and challenged 'the spread of communism' (to the extent that it attacked the activities of American corporations that sought to do business with communist states). By reversing this phrase and using it to caption an alluring photograph of a young woman dressed in Hollywood's conception of native American Indian costume, the image appealed to the Counter Culture's taste for pre-modern or 'tribal' lifestyles (represented by the fashion for communes, beads and tepees in the late 1960s) and nascent anti-Americanism.

SPEAKING FOR VIETNAM

In 1968 eight artists were invited to lend their skills as image-makers to protest against the war in Vietnam and promote a series of events in France in March. The prominent Abstract Expressionist painter Alfred Manessier produced the image below, which suggests a wracked landscape under a blue sky. The poster identifies neither aggressors nor victims, except perhaps the environment itself, which at that time was being systematically destroyed by the defoliants used by US forces. By contrast, Paul Rebeyrolle's image is more explicit, depicting in his characteristically expressionist style a scrawny American eagle in the hands of a North Vietnamese fighter.

Paul Rebeyrolle, *Journée des intellectuels pour le Viet-Nam* ('The Day of Intellectuals for Vietnam'). France, 1968. V&A: E.1844–2004

Alfred Manessier, *Journée des intellectuels pour le Viet-Nam* ('The Day of Intellectuals for Vietnam'). France, 1968. V&A: E.1841–2004

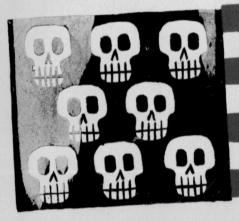

THE PLAGUE IN VIETNAM

President Richard Nixon secured office in 1968, in part by promising a phased withdrawal of American troops from Vietnam and a de-escalation of the conflict. In fact, in 1970 he announced that the war against the Vietcong was being extended into Cambodia, a decision taken without the agreement of Congress. Nixon's new course triggered demonstrations and riots throughout North America and Europe. This poster produced by university students in

Paris represented Nixon's policy as a man-made plague as virulent as Nazism (represented in the substitution of the 'x' in the President's name for a swastika). The horizontal bands of the Stars and Stripes seem to turn into curling clouds, perhaps representing the use of napalm in Vietnam. One American pilot described its 'improvement' in the early 1970s:

the 'backroom boys' started adding Willie Peter (WP = white phosphorous) so's to make it burn better. It'll even burn under water now. And just one drop is enough, it'll keep on burning right down to the bone so they (the Vietnamese) die anyway from phosphorous poisoning.[18]

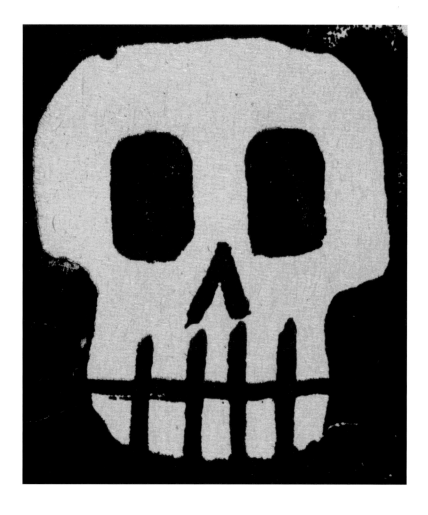

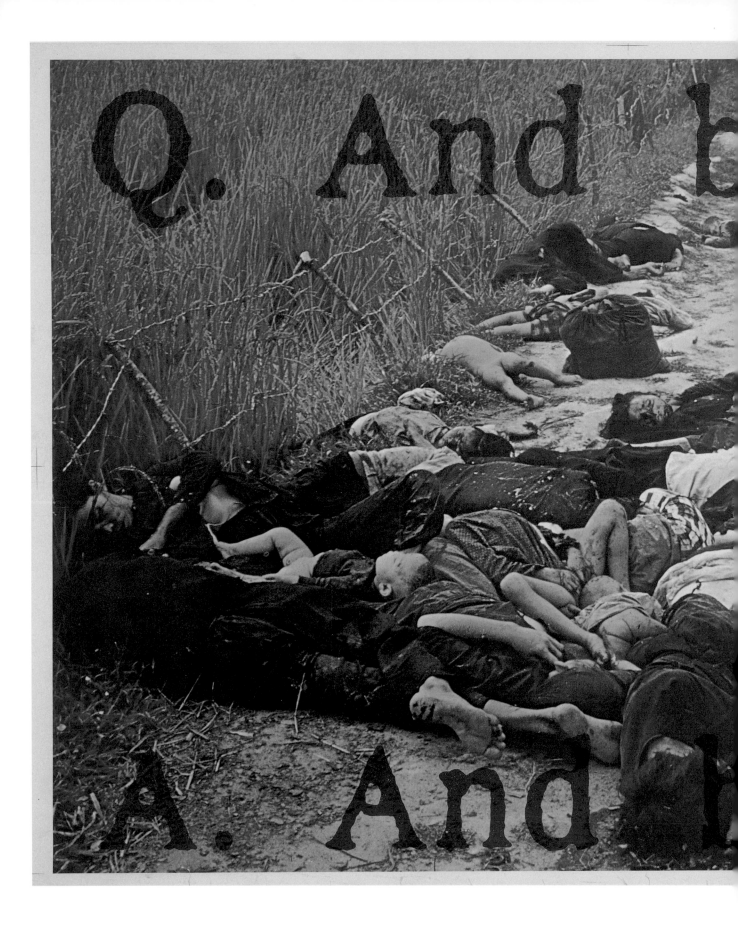

Posters of the Cold War

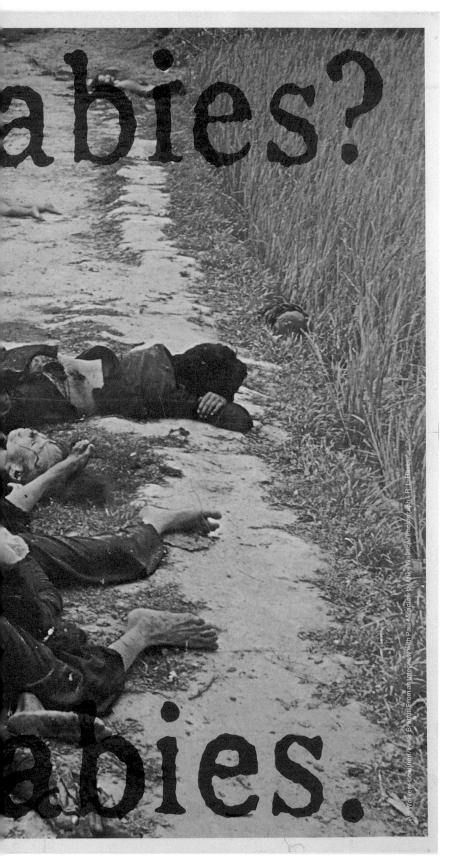

AND BABIES?

In 1968 a troop of US soldiers massacred the population of a Vietnamese village, Mai Lai. The 106 people who died in this brutal episode were initially described by a US army spokesman as a Vietcong unit. The evidence provided by the Army's own photographer revealed, however, that men and women, old and young, had been killed indiscriminately. The images of the dead, as well as other shots of peasants recoiling from the menacing GIs, found their way into the American mass media. They were shown on the major news broadcasts without commentary, such was their shocking force.

The images appeared at a time when American attitudes to the war were already changing. Even for those who had been loyal supporters of Lyndon B. Johnson's decision to limit the spread of communism throughout South-East Asia by sending in American forces, they triggered a crisis of confidence. For the anti-war movement, here was brutal evidence of indifference and violence done to the very people America was claiming to protect. The Art Workers Coalition published this poster, based on an image that had caused a storm of controversy when it was broadcast on American television. The caption added sensational force to the terrible image, quoting one of the GI participants who was interviewed about the events of the day. When asked whether the troops had shot civilians, he replied: 'And civilians'. 'And babies?', asked the interviewer; the chilling answer was: 'And babies'.

Art Workers Coalition, photograph by Ron Haeberle, *Q. And babies? A. And babies*. USA, 1970. V&A: E.233–1985

ONE DAY IN HANOI

Shot on location by a Cuban film crew, the documentary film promoted by Alfredo Rostgaard's poster represents the life of the people of North Vietnam over the course of one day in 1967. The film contrasts the storm unleashed by American warplanes over the capital city and their calm efforts to survive. Rostgaard's spare design represents President Lyndon B. Johnson's face as the warhead on two identical bombs falling against a symbolic red background. Such was the high consciousness of events in Vietnam in the minds of the Cuban viewer that nothing else was needed to explain the subject of Santiago Álvarez's film. In 1967 Che Guevara had sent his last missive — 'from somewhere in the world' — to OSPAAAL (see page 65). It denounced American involvement in Indochina, saying: 'US imperialism … transform[s] the whole zone into a dangerous detonator ready at any moment to explode.' Rostgaard crystallized Che's message into a powerful image.

Alfredo Rostgaard,
Hanoi — Martes 13,
('Hanoi — Tuesday 13'),
film poster produced
by Instituto Cubano
del Arte e Industrias
Cinematográficos.
Cuba, *c.***1967.**
V&A: E.1975–2004

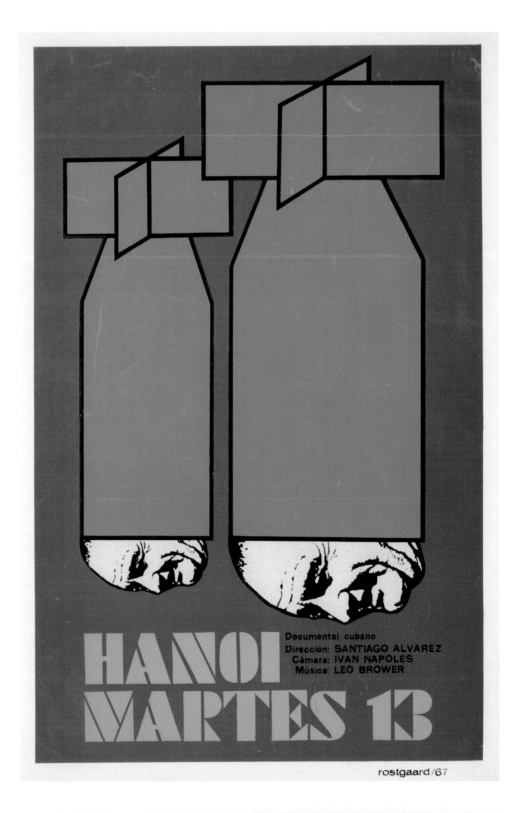

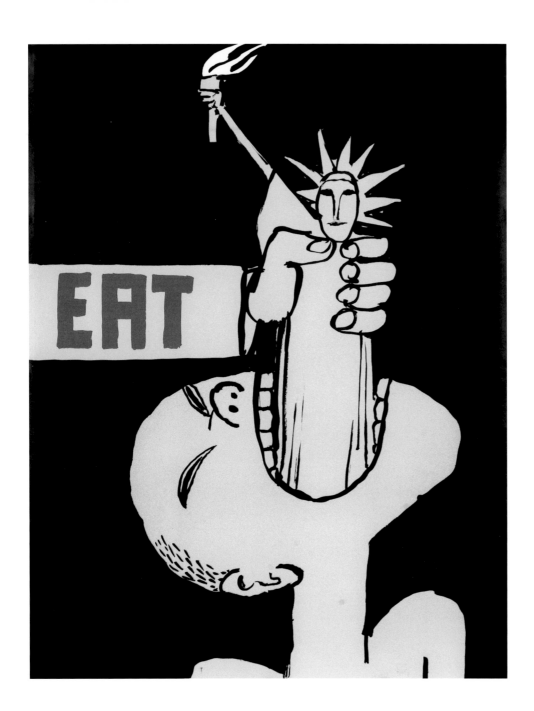

Tomi Ungerer, *EAT*,
anti-Vietnam War poster.
USA, 1967.
V&A: E.145–2004

EAT

In this powerful critique of American foreign policy, the celebrated graphic designer and children's book illustrator Tomi Ungerer depicted the symbol of welcome to the United States, the *Statue of Liberty* (a figure who announces to the world, 'give me your poor, your huddled masses, yearning to breathe free'), as a symbol of violence. A Vietnamese figure is compelled to consume this American gift with the bold injunction 'EAT'. The emphasis suggests a second critique of American foreign policy: in asserting

freedom around the world in the face of the spread of communism, Washington was demanding the conditions in which people would become free to consume American commodities.

Making a clear opposition to the actions of the Pentagon and the White House in Indochina, the poster has been criticized for representing the people of Vietnam as victims, when, in fact, the Vietcong (North Vietnamese forces) were proving to be very difficult to overcome, even before the Tet Offensive of early 1968, when the North launched a massive attack on South Vietnam and its American allies.

PEACE IN INDOCHINA

When Saigon, the capital of South Vietnam, fell to Vietcong forces in April 1975, the war in Vietnam was effectively over. The withdrawal of American troops constituted the first major military defeat for the United States. Vietnam was then unified under the communist government of the North.

Facing page:
Unknown designer,
Peace in Indochina is a
Victory for Us All.
USA, probably 1975.
V&A: E.315.2004

The poster opposite, produced in the USA in the mid-1970s, represents peace as a bucolic return to normality. This was hardly possible. Vietnam had been devastated: two million people had died and 1.3 million children had been made orphans; a quarter of the land and forests had been damaged by bombs and chemical weapons; and 70 per cent of industry had been destroyed. None of Washington's dire predictions about the 'Domino Effect' of a communist victory were realized after the formation of the Socialist Republic of Vietnam. Nevertheless, it is estimated that a further two million people sought to flee the country, many by sea, where they perished. Despite the heady rhetoric of this poster, no one was a victor in this conflict.

Grapus, ***Vietcong Flag.***
France, *c.***1975–6.**
V&A: E.1585–1979

There has never been an age, however rude or uncultivated, in which the love of landscape has not in some way been manifested.

JOHN CONSTABLE 1836

Photomontage © Peter Kennard 1983

Peter Gladwin and
Peter Kennard,
The Haywain, published
by the GLC. UK, 1983.
V&A: E.1501.2004

THE HAYWAIN AGAIN

The British artist Peter Kennard has maintained a tradition of political montage that can be traced back to artists such as John Heartfield in Weimar Germany. The technique works best when strikingly unsettling images are contrasted. In this image to promote disarmament, Kennard and Gladwin convert a haywain into a Cruise missile launcher. The original work painted in 1821 by John Constable represents Flatford Mill on the River Stour in Suffolk, where the artist was born. Kennard's montage published by the Greater London Council (GLC) followed the announcement by the Conservative government in 1980 that air bases, some in East Anglia close to Constable's birthplace, would be equipped with long-distance weapons capable of destroying Soviet cities. By selecting this idyllic vision of England, Kennard exposed the covert threat within the landscape.

GONE WITH THE WIND

President Reagan's first career as a Hollywood actor provided rich ammunition for political satirists in the 1980s. This poster depicts Reagan and the British Prime Minister Margaret Thatcher in the romantic clinch adopted by Vivien Leigh and Clarke Gable in the promotional material for the film of 1939. Bob Light's and John Houston's design focuses on the theme of nuclear fallout, particles contaminated with radioactivity that would fall to earth in the days following a nuclear explosion. Its effects

would be as lethal as the initial explosion. Reagan at that time was embarking on a dangerous acceleration of the arms race in an attempt to break the economic and military capacity of the Soviet Union.

Light and Houston threaded a vein of bitterly dark humour through the strap lines and ringing endorsements that accompany the image, which is a pastiche of B-movie posters. The 'Pentagon Production' appears to be funded by the International Monetary Fund and directed by Henry Kissinger, a member of the Nixon government, who was notorious for his hawkish views.

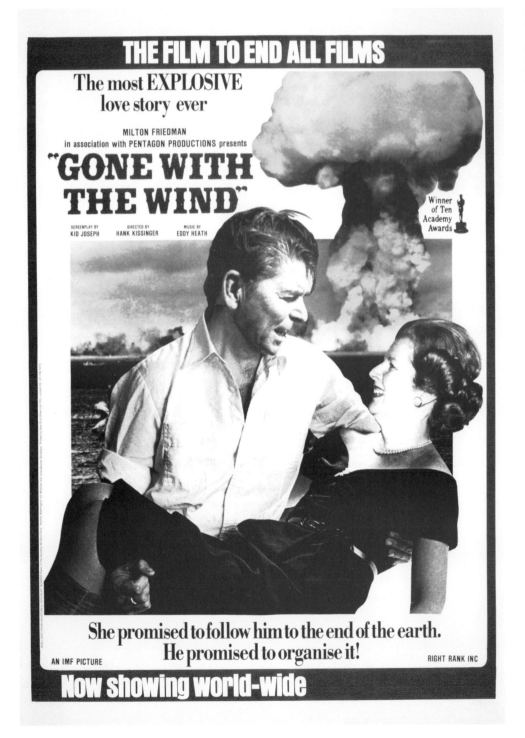

Bob Light and John Houston, *Gone with the Wind***, an anti-nuclear arms poster for the Socialist Workers Party. UK, 1983.
V&A: E.662.2004**

USA/USSR

The American-born artist Peter Paul Piech spent most of his life in Britain, where he established a reputation as a printmaker with a strongly political outlook. He was the founder of the Taurus Press in the late 1950s, which produced books often illustrated with his expressive linocuts and woodcuts. This large-format print reflects Piech's deeply held pacificism. It was produced at the height of the revived nuclear arms race of the 1980s, in which the Soviet Union and the USA vied to produce new Intercontinental Ballistic Missiles (ICBMs) capable of delivering nuclear warheads to distant targets. Treating the Soviet Union and the United States as moral equivalents in this Cold War competition, Piech labelled their weapons with their acronyms. They impale an agonized Christ-like figure on a cross. This martyr represents an everyman figure threatened by militarism.

Facing page:
Peter Paul Piech,
Untitled. UK, 1982.
V&A: E.771–1986

PAX SOVIETICA

When the communist authorities set out to stem the growing influence of the Solidarity trade union in Poland, this poster had to be printed in secret on an underground press. It satirizes the seemingly endless references to peace in Soviet propaganda and the brutal reality of communist rule by converting a peace dove into a tank (a direct adaptation of a Paix et Liberté poster produced in France in the early 1950s).

The image of the tank was not an empty symbol when the poster was produced. Martial law was declared in December 1981. Overnight, Polish army units with tanks and special riot-police squads in armoured vehicles rolled out of their garrisons to suppress dissent. Martial law ended formally 18 months later, in July 1983: the experience was not easily forgotten and contributed strongly to the national desire for self-determination, which was achieved in 1989 following the first democratic elections in the Eastern Bloc.

Overleaf:
Unknown designer,
Pax Sovietica, anti-communist poster.
Poland, 1982.
V&A: E.1398–1993

PAX SO

VIETICA

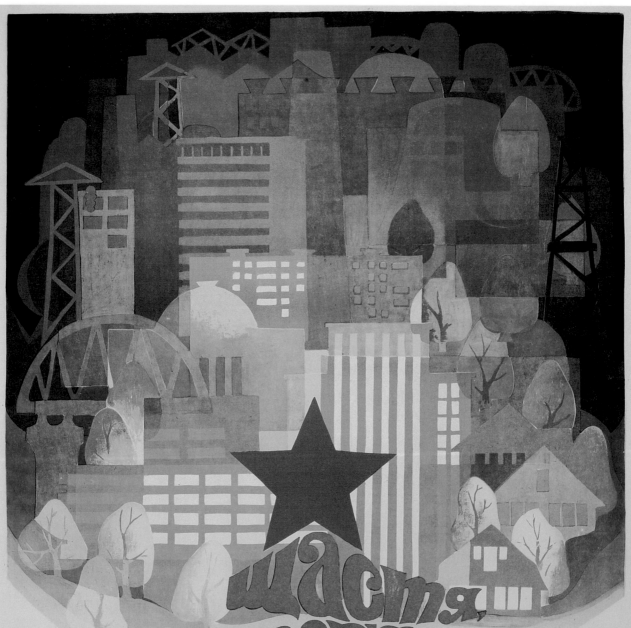

Щастя, здоров'я, трудових успіхів у новому році!

ДОВІДКА НА СІЛЬСЬКОГОСПОДАРСЬКІ
ТЕМАТИКИ № 116
ДОВІДКА НА ТЕМУ КОМУНІСТИЧНОГО
ВИХОВАННЯ МОЛОДІ № VII

4

POSTER POLITICS IN EASTERN EUROPE AFTER 1980

By the 1970s it seemed that the political poster in Eastern Europe had become little more than a moribund relic of revolutionary socialism, an anaemic version of the avant-garde aesthetics of the 1920s. Soviet poster designers had fallen into empty formulas: Lenin was forever on the tribune embodying the 'October spirit'; square-jawed workers were still toiling for the benefit of society; and red stars were constantly zipping into endless space. Even the much-fêted traditions of the Polish Poster School of the 1950s and early 1960s, and the Cuban poster of the 1960s, had passed into cliché, whilst sustaining the image of these two countries as relatively 'liberal' in the imagination of foreign observers.

On the streets of Moscow, Warsaw and Bucharest, political posters had taken on a surreal quality that was the defining feature of life in 'Absurdistan', as some ironic commentators called the Eastern Bloc. The gulf between the incessant promotion of triumphs in the economy and benefits of living in a socialist state whilst people queued for bread and had to tune into news reports on the BBC World Service or

Radio Free Europe (when their signals were not being jammed) for accurate reports of world affairs was wide, even unbridgeable. As the Czech writer and dissident Václav Havel noted in the mid-1970s, few living in the Eastern Bloc believed in the utopian rhetoric of communism any more. Of the posters on the streets, he wrote: 'the real meaning of a … slogan has nothing to do with what the text of the slogan actually says. Even so, this real meaning is quite clear and generally comprehensible because the code is so familiar'.[19] For Havel, the good comrade who pastes up Party posters 'declares his loyalty in the only way the regime is capable of hearing; that is, by accepting the prescribed ritual'. Official posters — in this world — were largely ignored, signifying little more than acquiescence to the status quo.

Moreover, the state held a monopoly on all forms of public expression. Censors wielding red pencils checked every message that went into print. Fearful of the spread of free opinion, the authorities controlled the use of even the most basic printing equipment. In Ceauşescu's

Facing page:
Unknown designer,
Happiness, Good Health, Success in Labour in the New Year.
Ukranian Soviet Socialist Republic, 1973.
V&A: E.1744–2004

**A printer working for
Solidarity in Poland in
1980 producing posters
calling for a general strike
(from Michael Yardley,
Poland: A Tragedy,
Sherborne, Dorset, 1982)**

Romania, for instance, all typewriters had to be registered with the state. As one commentator noted in 1970:

> The Soviet bureaucracy, that is to say the most widespread and complicated bureaucracy in the world, has to deny itself almost entirely an elementary piece of organizational equipment, the duplicating machine, because this instrument potentially makes everyone a printer. ... It is clear that Soviet society has to pay an immense price for the suppression of its own productive resources — clumsy procedures, misinformation, *faux frais*.[20]

During the period of Martial Law in Poland after 1981, when the government stamped down on Solidarity, the anti-communist alliance of intellectuals and workers, the police raided art schools to take away screen-printing equipment. Nevertheless, samizdat production continued illicitly there and throughout the Eastern Bloc. At the same time, what Tom Kovacs called the 'spirit of metaphor' shaped dissenting culture.[21] When, for instance, the famous Solidarity logo was banned, the Poles invented new symbols that did not draw the rancour of the state. Ordinary people would wear electronic resistors in the 'national' colours of red and white. Everyone knew what this gesture meant, but for the state and its henchmen to act against those wearing these tiny pins would have revealed the absurdity of the situation. 'Aesopian' parables and allegories found their way into many different kinds of posters. In a theatre poster of 1983 Henryk Tomaszewski sketched the image of a foot apparently making the 'V' gesture with its toes, a symbol that Solidarity leaders had adopted during the heady days of its rise. This was read as an allusion to the irrepressible spirit of the trade union then under prohibition.

In the 1980s two momentous shifts in the moribund political culture of the Eastern Bloc brought the poster back to life in a part of the world that was widely described as being 'stagnant'. Mikhail Gorbachev, who had taken the helm of the Communist Party in Moscow in 1985, announced the need for 'perestroika' (restructuring) and 'glasnost' (openness) in the Soviet Union. This was a genuine but desperate attempt to shore up the creaking hull of Soviet socialism as it recognized its own abuses of human rights and the insurmountable economic crisis. Almost overnight, it seemed that subjects that had hitherto been prohibited were publicized. Poster artists turned their attention to

what Gorbachev called the 'blank spots' of Soviet history. In 1990, for instance, Gorbachev was forced to admit that the Soviet secret police (NKVD) had murdered the Polish officer class in the forests around Katyn in western Russia during the Second World War at Stalin's behest, a massacre that the Soviet Union had long blamed on the Third Reich. Destructive social issues such as alcohol abuse were also put centre-stage. The jolt issued by these frank posters — as well as reports in the press and, later, films — was traumatic in a society that had become used to reading 'between the lines'.

The reform movement went much further in the People's Republics of Eastern Europe. The Solidarity movement in Poland had been suppressed but not extinguished in 1981: it continued to act as a powerful and social force, alongside the Catholic Church, a fact that forced the communist authorities to enter into negotiations with it in early 1989. One result of the round-table discussions were the democratic elections held in June, the first in the Eastern Bloc for forty years. Events went further and faster in other parts of the region: the Czechoslovaks enjoyed a peaceful 'Velvet Revolution' in November, when communist rule imploded in the face of overwhelming popular protest. The same month also saw the breaching of the Berlin Wall, once the most brutal symbol of Cold War division. In the course of 1989 and in the months that followed, poster designers were called upon to produce election posters for the nascent political parties that were emerging from the ruins of communist rule or to articulate popular opinions, like, for instance, the desire to see the withdrawal of the Red Army from its bases in Central Europe. Many of the designs drew upon the traditions of allusion and graphic wit that had kept dissent alive in the Bloc during the years of stagnancy.

Underground 'stamps' produced to raise funds for the suppressed Solidarity movement in Poland. Private Collection

STALINISM

In launching the policy of glasnost, President Gorbachev hoped to make the management of the Soviet economy transparent and open to debate. This was to be a means of ensuring the prospect of communism. Many of the debates addressed not the future, however, but the past. In relaxing its approach to censorship, many of the suppressed themes of Soviet history bubbled to the surface of public discussion. What had already been circulating in underground publications could become public knowledge. The Soviet media exposed the discovery of mass graves of the victims of the terror of the 1930s and reflections on the Stalin period, including Aleksandr Solzhenitsyn's *Gulag Archipelago*, published in the West in 1973, became available.

Leonov's poster was a prize-winning entry in a poster competition, *Perestroika and Us*, dedicated to the 70th anniversary of the VLKSM (All-Union Leninist Communist Youth League). Stalin, despite his blank eyes and mouth, is immediately recognizable. This poster offered a powerful yet enigmatic image of a man responsible for the murder of millions of people.

Facing page:
Yuri Leonov, *Stalinism,*
perestroika poster.
USSR, *c.*1989.
V&A: E.966–1990

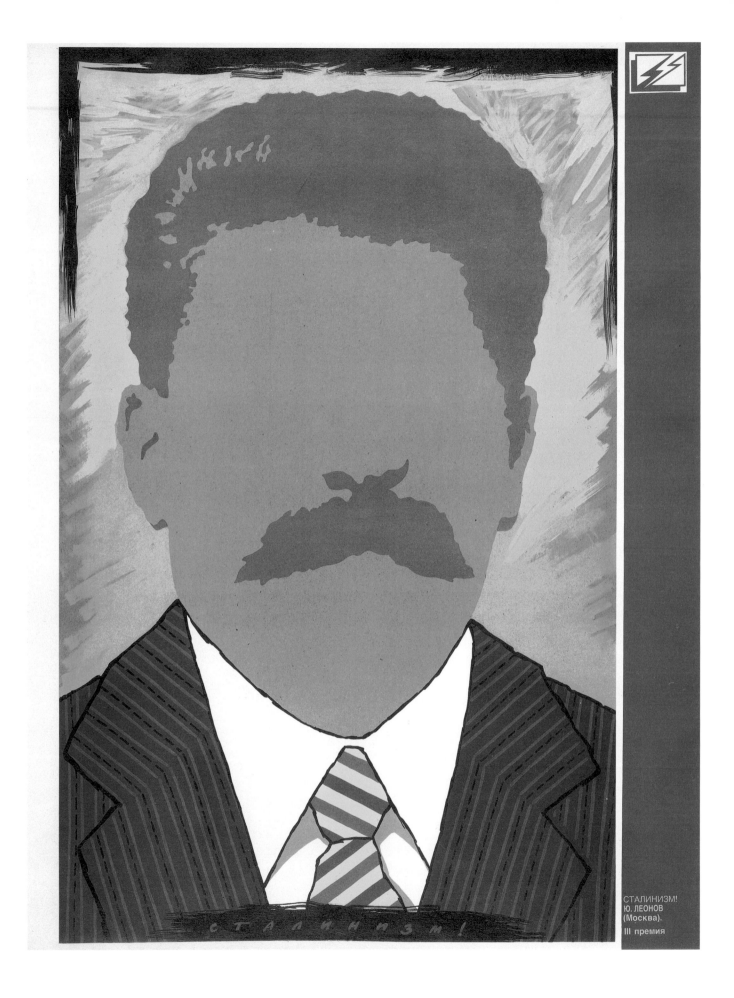

СТАЛИНИЗМ!
Ю. ЛЕОНОВ
(Москва).
III премия

WE SUPPORT DEMOCRACY

The policies of glasnost and perestroika in the Soviet Union represented a short period of realism at the end of the communist era during which different voices could criticize the failings of both the state and society. These frank exchanges were electric, often shocking a society long used to empty platitudes.

Glasnost and perestroika were not, however, designed to dismantle communist rule. In fact, a plenum of the Communist Party Central Committee in April 1985 set out to exonerate Lenin from the disasters that befell the Soviet Union in the years after his death. In this spirit, this late perestroika poster announces that 'the Revolution continues' and employs the bold and dynamic lettering tradition associated with Constructivism in the 1920s. By inserting a modern figure into this historic billboard (the kind of photogenic amusement found at the seaside), Yavin's design strikes an uncertain note about the value of commitment to Lenin's vision.

B. Yavin, *We Support Perestroika. The Revolution Continues. Begin Perestroika with Yourself. Democracy. Glasnost. To Tag Along We Shall Not Allow!* USSR, 1989. V&A: E.2151–1990

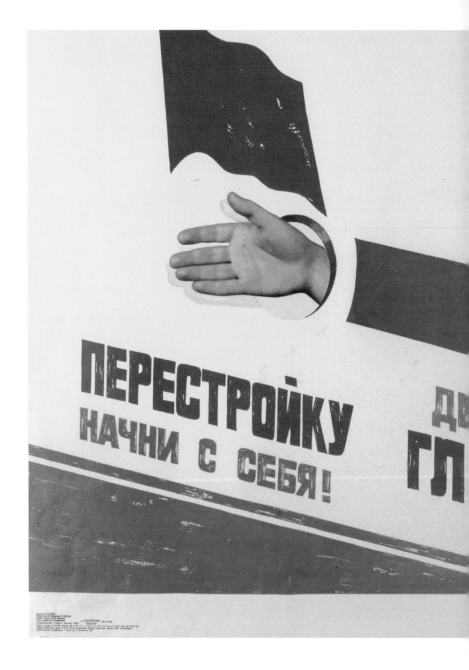

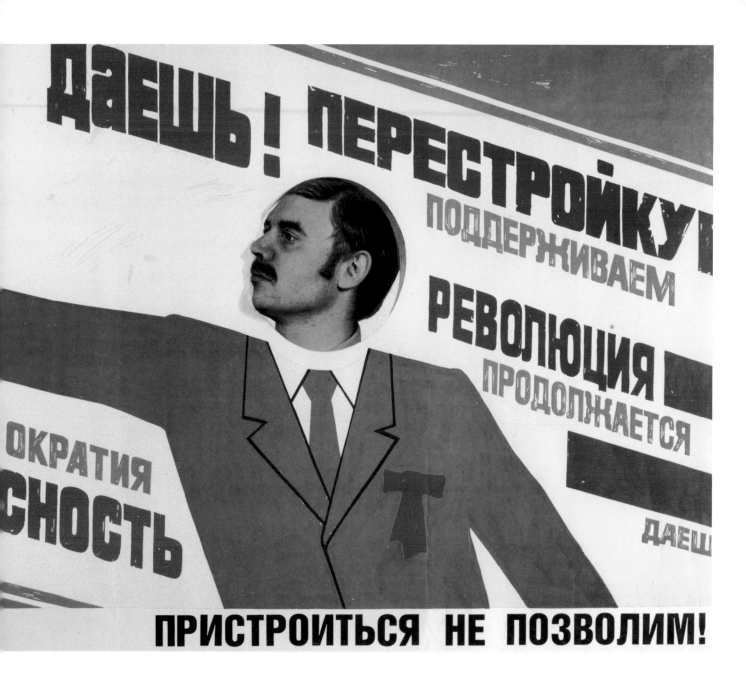

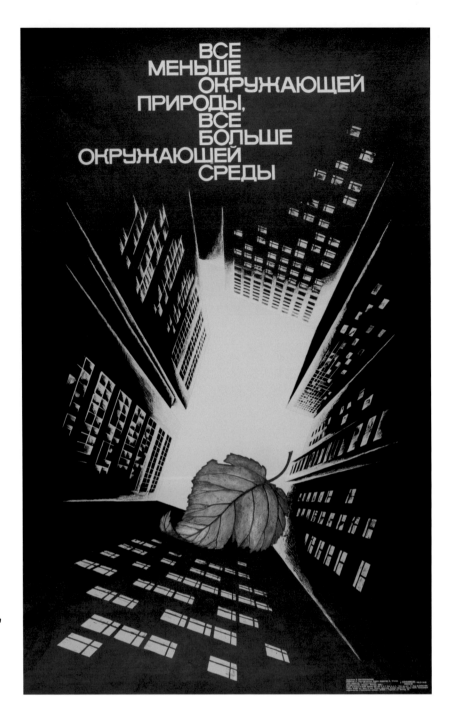

ВСЕ
МЕНЬШЕ
ОКРУЖАЮЩЕЙ
ПРИРОДЫ,
ВСЕ
БОЛЬШЕ
ОКРУЖАЮЩЕЙ
СРЕДЫ

Unknown designer,
*Even Less of the
Surrounding Nature, Even
More of the Surrounding
Environment*, a poster
produced during the
perestroika period.
Soviet Union, undated.
V&A: E.2053.1991

EVEN LESS NATURE

Perestroika allowed for explicit criticism of
the harmful effects of seventy years of Soviet
modernization. Goskompriroda, the state
committee for the protection of nature, pub-
lished shocking reports on the state of the
environment of Russia and the other Soviet
republics in the late 1980s. The Marxist-Leninist
emphasis on industry as the engine of social
transformation had had devastating effects.
The Aral Sea, for instance, was effectively

deprived of the rivers that once fed it to serve
the Soviet cotton industry. In the course of the
1960s the sea began to shrink, turning its
shores into a desert populated with beached
ships. Acid rain was destroying the vast forests
of north-western Siberia, creating a lifeless
wilderness. At the same time, Soviet cities were
unrelentingly drab and polluted environments.
This melancholic poster symbolizes nature
in the form of a desiccated leaf fluttering from
a distant blue sky in a menacing, man-made
environment. The tree from which it fell is
nowhere to be seen: perhaps this is the last leaf.

HIGH NOON

Tomasz Sarnecki's poster was one of the most memorable images of the elections of June 1989 in Poland, a crucial moment in the democratic revolution in Eastern Europe. Promoting the popular anti-communist trade union Solidarity, it represents the elections as the moment when the Communist Party will be brought to justice. The pistol that Gary Cooper had carried in the Hollywood western *High Noon* (1952) is replaced by the ballot paper, metaphorically identifying an impending change from rule by force to rule by ballot box. By employing an archetypal symbol of the West, Sarnecki's poster carries other symbolic dimensions: communism's critics in Poland had long felt that the country did not belong to the autocratic East represented by the Soviet Union. As Sarnecki's poster makes clear, the election marked an important step 'back' to the West. His design, perhaps unconsciously, tapped another truth about politics in the West, that it is closely entwined with entertainment.

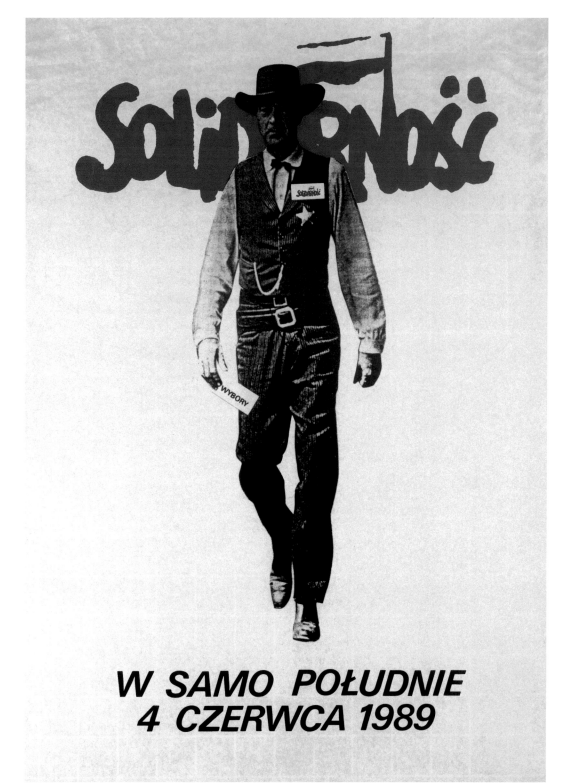

Tomasz Sarnecki, *High Noon*, election poster issued by Solidarity Independent Trade Union. Poland, 1989. V&A: E.3125–1990

COMRADES IT'S OVER!

Soviet troops occupying army bases throughout Eastern Europe were widely regarded as occupying forces. This was particularly true in Hungary, where the memories of the repression of the Hungarian Uprising in 1956 were still alive in the 1980s. For many people in the region, the most important guarantee of the end of communist rule was the withdrawal of the Red Army.

This poster is a later version of a design first produced during the final phases of communist rule in Hungary. Its artist, the illustrator and printmaker István Orosz, produced it independently and pasted it up in the streets of Budapest. It was then adopted by the Magyar Demokrata Fórum (Hungarian Democratic Forum) during the first democratic elections that followed the collapse of Communist rule. Although it was a potent declaration of opposition to the presence of Soviet troops in Eastern Europe, Russian soldiers queued to buy a copy of it as a souvenir when the Red Army left Hungary in 1991.

István Orosz, *Tovarishi koniets!* ('Comrades It's Over!'), political poster issued by the Magyar Demokrata Fórum (Hungarian Democratic Forum). Hungary, 1990. V&A: E.2034–1990

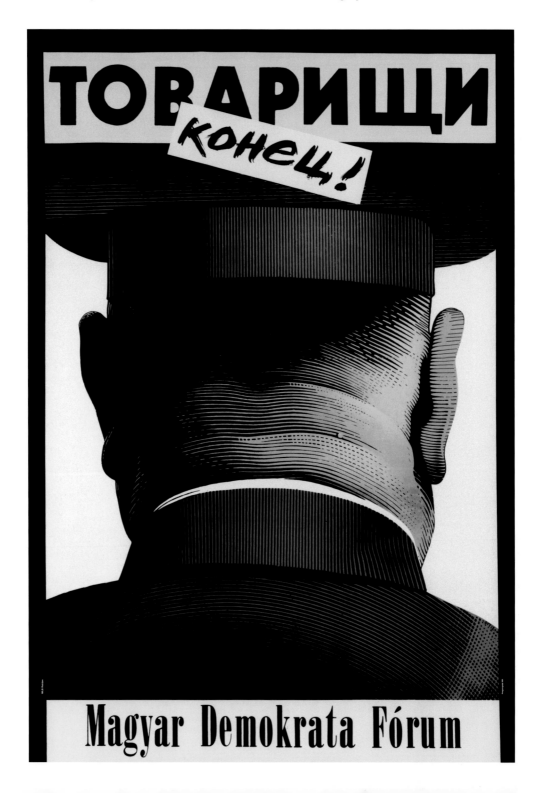

Krzysztof Ducki, *Aurora*,
a poster to promote an
exhibition of his designs.
Hungary, 1989.
V&A: E.157.1991

AURORA

When, towards the end of the Soviet experiment
in Eastern Europe, artists were unshackled
from censorship, many chose to comment on
the experiences of socialism. Not all images
were strident works of anti-communist propa-
ganda. Krzysztof Ducki, a poster designer
based in Budapest, selected the theme of the
Aurora, the tsarist battleship that joined the
October Revolution in St Petersburg in 1917 on
the side of the Bolsheviks, as the subject of
a poster printed to promote an exhibition of his

work in Komárom in March 1989. Although
the most dramatic events of the year were
yet to happen, such as the fall of the Berlin
Wall, Hungary was already freeing itself
of Soviet rule: the Hungarian parliament, for
instance, guaranteed the democratic rights
of independent political parties in January.

An intentionally ambiguous work, Ducki's
design shares the preoccupation with the
dynamic layouts and reduced colour
schemes favoured by Soviet Constructivist
designers of the 1920s: yet his *Aurora*
seems to be sinking.

Krzysztof Ducki,
Praha '68 ('Prague '68').
Hungary, 1989.
V&A: E.161–1991

PRAGUE '68

The Hungarian graphic designer Krzysztof Ducki was in Prague in November 1989 when the Velvet Revolution swept the communists from power in Czechoslovakia. For the first time in twenty years, it became possible to reflect openly on the events of August 1968, when Soviet-led forces suppressed the Prague Spring reform movement. Czech and Slovak towns and cities had seen their streets fill with the tanks and troops of their Warsaw Pact 'allies'. The response of their citizens largely took the form of sponta-neous acts of non-violent resistance.

The Soviet press represented the invasion as the fraternal assistance of one socialist nation to another. The new Czech leadership under Gustáv Husák sought to 'normalize' the country's political situation. Public discus-sion of the events of 1968 were largely prohibited, with the Party requiring a kind of short-term amnesia on the part of the people. But as Milan Kundera, the novelist who went into exile in 1968, famously observed, 'the struggle of man against power is the struggle of memory against forgetting'.[22] Ducki's direct design is a simple act of testimo-nial, an image of events that only recently had been shrouded in silence.

VOTE WITH YOUR HEAD

Although other posters produced by the Vereinigte Linke (United Left), an alliance of left-wing political groups, for the March 1990 elections to the East German parliament were cheaply printed in black, then hand-coloured in red crayon or felt-tip pen by party workers, this lithographic poster was printed in colour. Nevertheless, it reflects on the urgency and excitement of events following the collapse of communist rule in East Germany. It asks the voter to consider the policies of the parties contesting the election rather than 'punishing' the Left in the ballot box for its associations with the communist government before 1989. The poster's intentionally 'primitive' style echoes the paintings of the Neue Wilden (New Fauves) in West Germany including Georg Baselitz and A.R. Penck who were held in high international regard around the world. There is perhaps a little unintended irony in this fact as a number of artists associated with the movement had fled East Germany for life in the West in the 1950s.

Unknown designer,
Deutschland is it?
('Germany is it?').
East Germany, 1990.
V&A: E.2083–1990

THE REAL THING

The Alliance of the United Left (Aktionsbündnis
Vereinigte Linke / AVL) was formed out of the
ruins of the Socialist Unity Party of Germany
(Sozialistische Einheitspartei Deutschlands / SED)
to contest the elections of March 1990 for the
Volkskammer. The election was, in effect, a
plebiscite for the reunification of Germany. This
design sought to raise the spectre of the Ameri-
canization of the country through one of its most
powerful symbols of capitalism, Coke. Using the
brand's characteristic colour scheme and lettering,
the AVL asked the viewer whether a united
Germany would mean the consumption of East
Germany by the market. The answer was clear
when the conservative Alliance for Germany
effectively won and set about working for reunifi-
cation, an event that took place in October 1990.

NOTES

1 Hans Magnus Enzensberger, 'Constituents for a Theory of the Media', *New Left Review* (November–December 1970), vol.1, no.64, p.27.

2 Andrei Zhdanov, speech delivered at a conference of representatives of a number of communist parties held in Poland in the latter part of September 1947. The speech was itself a response to Truman's declaration of 'Two Worlds'. See Geoffrey Roberts, 'Moscow and the Marshall Plan: Politics, Ideology and the Onset of the Cold War, 1947', *Europe-Asia Studies* (1994), vol.46, no.8, pp.1371–86.

3 Louis Aragon (1951), cited by Richard Kuisel, *Seducing the French* (Berkeley and Los Angeles, 1996), p.41.

4 Michael Shamberg and Raindance Corporation, *Guerrilla Television* (New York, 1971), p.3.

5 Khrushchev cited by Odd Arne Westad, 'Reviewing the Cold War'. *Approaches, Interpretations, Theory* (London, 2000), p.308.

6 David Riesman, *Abundance for What? And Other Essays* (Garden City, NY, 1964), pp.65–77.

7 See Stephen J. Whitfield, *The Culture of the Cold War* (Maryland, Baltimore, 1996), p. 32.

8 Jean-Paul Sartre, cited by Jon Lee Anderson, *Che Guevara: A Revolutionary Life* (New York, 1998), p.624.

9 Guevara cited by Jorge G. Castañeda, *Companero: The Life and Death of Che Guevara* (New York, 1997), p.291.

10 Raoul Vaneigem, 'Spurious Opposition', *The Revolution of Everyday Life* (London, 1967).

11 *Posters from the Revolution, Paris, May 1968* (London, 1969), p.3.

12 Susan Sontag 'Posters: Advertisement, Art, Political Artifact, Commodity', in Douglas Stermer (ed.), *The Art of Revolution: Castro's Cuba, 1959–1970* (London, 1970), p.xxii.

13 Ibid., p.xvii.

14 Kennedy cited by John Hare, 'Credibility and Bluff' in Avner Cohen and Steven Lee (eds), *Nuclear Weapons and the Future of Humanity: The Fundamental Questions* (Lanham, MD, 1986), p.191.

15 Peter B. Hales, 'The Atomic Sublime', *American Studies* (Spring 1991), 32, pp.5–31.

16 Steven Heller, 'Erik Nitsche: The Reluctant Modernist' at www.typotheque.com (accessed December 2007)

17 Herman Kahn, cited in Margot Henriksen, *Dr Strangelove's America: Society/Culture in Atomic Age* (Berkeley, 1997), p.203.

18 Cited by Noam Chomsky, *The Backroom Boys* (London, 1973), p.23.

19 Václav Havel 'The Power of the Powerless' (October 1978) in *Open Letters*, trans. Paul Wilson (New York, 1991), p.136.

20 Hans Magnus Enzensberger, 'Constituents for a Theory of the Media', *New Left Review* (November–December 1970), vol.1, no.64, pp.15–16.

21 T. Kovacs, 'The Spirit of Metaphor: An Alternate Visual Language', *Il Mobilia*, 322 (1984), pp.17–20.

22 Milan Kundera, *The Book of Laughter and Forgetting* (London, 1981), p.3.

FURTHER READING

Aulich, J., and Sylvestrová, M., *Political Posters in Central and Eastern Europe, 1945–95* (Manchester, 1999)

Bonnell, Victoria E., *Iconography of Power: Soviet Political Posters under Lenin and Stalin* (Berkeley, CA, 1997)

Brooks, Jeffrey, *Thank You, Comrade Stalin!: Soviet Public Culture from Revolution to Cold War* (Princeton, NJ, 2000)

Buck-Morss, Susan, *Dreamworld and Catastrophe: The Passing of Mass Utopia in East and West* (Cambridge, MA, 2000)

Caute, David, *The Dancer Defects: The Struggle for Cultural Supremacy during the Cold War* (New York, 2003)

Colomina, B., Brennan, A., and Kim, J. (eds), *Cold War Hothouses: Inventing Postwar Culture from Cockpit to Playboy* (New York, 2004)

Cushing, Lincoln, *Revolucion!: Cuban Poster Art* (San Francisco, CA, 2003)

Davidson, Russ (ed.), *Latin American Posters: Public Aesthetics and Mass Politics* (Santa Fe, NM, 2006)

Durant, Sam, et al., *Black Panther: The Revolutionary Art of Emory Douglas* (New York, 2007)

Evans, H., and Donald, S., *Picturing Power in the People's Republic of China: Posters of the Cultural Revolution* (Lanham, MD, 1999)

Gaddis, John Lewis, *The Cold War: A New History* (Harmondsworth, 2005)

Glaser, Milton, *The Design of Dissent: Socially and Politically Driven Graphics* (Gloucester, MA, 2006)

Hanhimäki, J.M., and Westad, O.A. (eds), *The Cold War: A History in Documents and Eyewitness Accounts* (Oxford, 2004)

Hill, Katie (ed.), *The Political Body: Posters from the People's Republic of China* (London, 2004).

Hixson, Walter L., *Parting the Curtain: Propaganda, Culture and the Cold War, 1945–1961* (New York, 1997)

Hobsbawm, Eric J., *Age of Extremes: The Short Twentieth Century, 1914–1991* (London, 1994)

Kurpik, Maria, *Żądło propagandy PRL-u 1945–1956* (Warsaw, 2006)

Lafont, Maria, *Soviet Posters: The Sergo Grigorian Collection* (Munich and London, 2007)

McQuiston, Liz, *Graphic Agitation: Social and Political Graphics since the Sixties* (London, 1993)

McQuiston, Liz, *Graphic Agitation, 2: Social and Politicalg Graphics in the Digital Age* (London, 2004)

Minck, S., and Ping, J., *Chinese Graphic Design in the Twentieth Century* (London, 1990)

Patchett, Tom, *Decade of Protest: Political Posters from the United States, Vietnam, Cuba, 1965–1975* (Santa Monica, CA, 1996)

Poynor, Rick (ed.), *Communicate: Independent British Graphic Designe since the Sixties* (London, 2005)

Rickards, Maurice, *Posters of Protest and Revolution* (Bath, 1970)

Schnapp, Jeffrey T., *Revolutionary Tides: The Art of the Political Poster, 1914–1989* (Milan, 2005)

Schwartz, Richard Alan, *Cold War Culture: Media and the Arts, 1945–1990* (New York, 2000)

Stermer, Dugald, *The Art of Revolution* (New York, 1970)

Timmers, Margaret (ed.), *The Power of the Poster* (London, 1998)

Walker, Martin, *The Cold War: A History* (New York, 1993)

Waschik, K., and Baburina, N., *Werben für die Utopie: Russische Plakatkunst des 20. Jahrhunderts* (Bietigheim-Bissingen, 2003)

Westad, Odd Arne, *The Global Cold War: Third World Interventions and the Making of our Times* (Cambridge, 2005)

Whitfield, Stephen J., *The Culture of the Cold War* (Baltimore, MD, 1996)

PICTURE CREDITS

Lázaro Abreu: p.65 and inside front flap

Atelier Populaire: pp.7, 48 ,57

E Felix Beltran: p.32

Moravské Galerie, Brno: p.61 and inside flap

Eliza Brownjohn: p.69

Estate of R. Buckminster Fuller: pp.42, 43

CDU, Christlich Demokratische Union: pp. 28, 29

Roman Cieślewicz/© ADAGP, Paris and DACS London 2008/National Museum, Poznań: p.50 and front cover

Emory Douglas: pp.63, 65 and inside flap

Krzysztof Ducki: pp.103, 104

Peter Gladwin: p.86

Grapus: pp.2, 85

Ron Haeberle: pp.80–81

F H K Henrion, C. Marion Wesel-Henrion: p.73 and back cover

Hans Hillman: p.56

John Houston: p.87

Instituto Cubano del Arte e Industrias Cinematográficos (ICAIC): pp.50, 58, 60

Norman Julia: p.47

Peter Kennard: p.86

Korda / DACS London 2008: p.64

Viktor Koretzky: pp.24, 25, 30 and back flap

C. Juri Leonov: p.96

Robert Leydenfrost/Leslie, Judith and Gabri Schreyer and Alice Schreyer Batko: p.13

Bob Light: p.87

Robert McCall: pp.2, 38, 52 and back cover

Alfred Manessier: pp.77b and back flap

Adolfo Mexiac: pp.45

Reginald Mount and Eileen Evans: p.33

Organization of Solidarity of the People of Asia, Africa and Latin America (OSPAAAL): p.65

Vojtek Němeček: p.66

Niko: pp.2, 50, 60

Erik Nitsche: p.70

István Orosz: p.102

Panek: p.75 and back flap

Pablo Picasso: © Succession Picasso/DACS 2008 front flap: pp.66, 72 and front flap

Peter Paul Piech: p.88

Private Collections: pp.17, 21, 30, 55, 75 and inside flap

Robert Rauschenberg: p.41

Paul Rebeyrolle: p.77a

Alfredo Rostgaard: p.82 and front flap

Václav Ševčik: p.61 and inside front flap

Solidarno: pp.2, 90–91

Tomasz Szarnecki: pp.101

Sony Pictures Entertainment: p.8

Karel Šourek: p.15

Świat: p.7

Karel Thole: p.16 and back flap

C. Angela Thomas Schmid/ pro litteris, Zurich: pp.18,19

Yuri Tsarev: p.40

Tomi Ungerer: p.83

Gaston van den Eynde: pp.2, 20

Vadim Petrovich Volikov: p.36

Michael Yardley: p.94

B. Yavin: p.98–99, inside flap and front flap

Courtesy of the Victoria and Albert Museum/Gift of the American Friends of the V&A; Gift to the American Friends by Leslie, Judith and Gabri Schreyer and Alice Schreyer Batko: pp.9, 12, 13, 17, 22, 24, 25, 32, 45, 46 and inside flap, 57, 62, 64, 65, 70, 72, 76 and inside flaps, 77 above, 77 below and inside flap, 78, 79, 83, 82 and front and inside flaps, 84, 86, 87, 92

Courtesy of the Victoria and Albert Museum: pp. 2, 3, 20, 33, 53, 41–43, 48, 51, 52, 58, 60, 73, 77, 78, 80–81, 85, 88, 90–91, 96, 98, 99, 100, 101, 102, 103, 104, 105, 106–107 and back cover

INDEX